WILDLIFE ANATOMY

THE CURIOUS LIVES & FEATURES OF WILD ANIMALS AROUND THE WORLD

JULIA ROTHMAN

BEST-SELLING AUTHOR OF THE ANATOMY SERIES

WITH HELP FROM LISA HILEY

The mission of Storey Publishing is to serve our customers by
publishing practical information that encourages
personal independence in harmony with the environment.

Storey books are available at special discounts when purchased in bulk for
premiums and sales promotions as well as for fund-raising or educational use.
Special editions or book excerpts can also be created to specification. For
details, please call 800-827-8673, or send an email to sales@storey.com.

Storey Publishing
210 MASS MoCA Way
North Adams, MA 01247
storey.com

Printed in China by R.R. Donnelley
10 9 8 7 6 5 4 3 2 1

Library of Congress Cataloging-in-Publication Data on file

For Ollie, who
loves alpacas
(and all other
 animals, too)

CONTENTS

INTRODUCTION

My sister, Dr. Jessica Rothman, studies primates in the forests of Uganda, Africa. The focus of her research is primate nutrition: how forest monkeys and mountain gorillas meet their nutritional needs through interactions with their environment. Since 1997—for 25 years!—she's been studying apes and monkeys in Uganda. First as a student herself, and now she's a professor, teaching others about primates at CUNY's Hunter College. She's in New York City for half the year and spends the other half in Uganda living in a small house in the park next to other scientists also studying wildlife. (Sometimes when I FaceTime her, she shows me baboons hanging out on her front porch.)

My sister's house in Uganda.

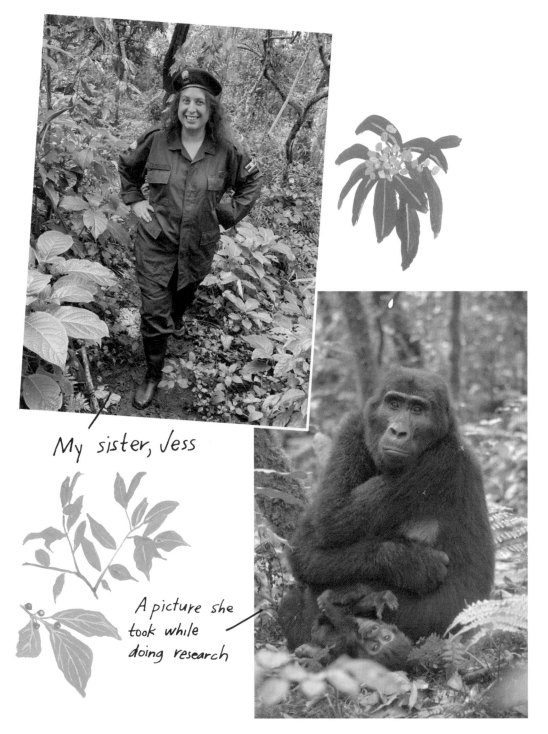

My sister, Jess

A picture she took while doing research

Jess's program also focuses on conservation and training through strong linkages with the Uganda Wildlife Authority and Makerere University. A few months ago, she told me about two of the promising students and told me they needed funding to get their master's degrees. I was excited to help.

I am using all of my advance royalty payment to help these two students.

By buying this book, you've helped support them, too!

Nusula Sarah Namukasa

66 As an undergraduate, I did a study of the diets of rhinos in a largely protected sanctuary in Uganda. I studied rhinos with a desire of becoming a rhino specialist. Everyone at school calls me "Mama Rhino." I learned a lot about rhino behaviour and the herbaceous plants rhinos eat. It brings me enjoyment and excitement. Now it's time to learn more about why they eat those plants and gather information about rhino nutrition, like the protein and minerals they consume. The information obtained will be used as a basis for rhino re-introduction into the wild. 99

Nandutu Esther

"I have worked at Uganda Wildlife Conservation Education Centre for four years now as a zookeeper and I have always been fascinated by the giraffes. I am pursuing a master's in zoology, and my career aspiration is to become a researcher. My research goal is understanding giraffe feeding and how they meet their nutritional needs. I am also trying to learn how the foods in their habitats might be changing due to climate change."

If you'd like to help students, too, see page 205 for information on supporting a fund my sister has started. The money goes directly to Ugandan students. We've also compiled a list of a few other wildlife conservation organizations.

Thank you and I'd love to hear what you think of the book. I see all of your Instagrams and tweets and get all of your emails and letters. Even when I'm too busy to reply, please know I am so happy to receive them.

Julia Rothman

CHAPTER 1

The World Over

EVERYTHING IS AN ECOSYSTEM

An ecosystem is a geographic area that sustains an interconnected web of plants, animals, and other organisms. Factors such as weather and the landscape are also part of the ecosystem. Each part of an ecosystem depends on the other parts for survival.

Ecosystems exist everywhere: in tiny tidal pools and urban parks, underground and on tops of trees, and across vast expanses of land, such as the Sahara or the rainforests of South America.

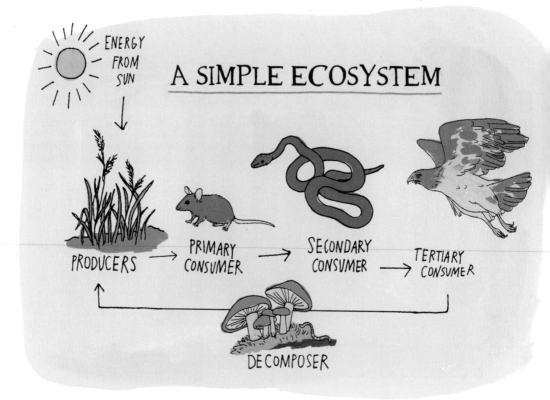

ENERGY FROM SUN

A SIMPLE ECOSYSTEM

PRODUCERS → PRIMARY CONSUMER → SECONDARY CONSUMER → TERTIARY CONSUMER

DECOMPOSER

EASTERN CHIPMUNK

Deciduous Forests

Deciduous forests have four distinct seasons: winter, spring, summer, fall. Winters are cold and summers are warm. Between 30 and 60 inches of rain fall each year. Deciduous forests are found in the eastern United States, Canada, Europe, China, and Japan.

Fertile soil supports a wide variety of plant species, with leafy trees being the largest. Typically, shrubs and other low-growing plants create a secondary layer, with mosses, lichens, wildflowers, ferns, and other small plants filling the forest floor.

The variety of plant life provides food and shelter for many different animals, from insects to birds to mammals. Reptiles and amphibians are common.

RED FOX

COMMON TOAD

Rainforests

Rainforests create their own weather by recycling water. Evaporating moisture rises during the day, forming vapor clouds that produce rain. Thick vegetation and tall trees are hallmarks of the two types of rainforest: temperate and tropical. Both types support a huge variety of plant and animal life.

TEMPERATE RAINFORESTS are found mostly along coastlines, which makes them wet and cool. They can receive 100 to 200 inches of rain per year. The largest temperate rainforest in the world runs for 2,500 miles, from Northern California to Alaska.

PACIFIC GIANT SALAMANDER

TROPICAL RAINFORESTS are found along the equator and are much hotter, with an average daily temperature of about 75°F (24°C). They are also much more humid, which helps generate up to 400 inches of rain per year.

TOUCAN

Bromeliads gather water in their centers. These small pools form their own ecosystems that support bacteria, insects, frogs, crustaceans, and even birds.

Deserts

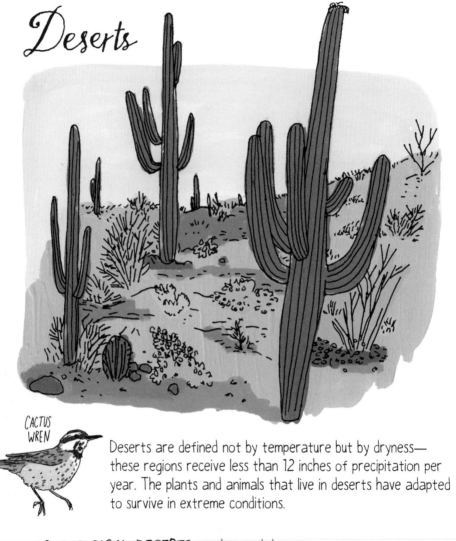

CACTUS WREN

Deserts are defined not by temperature but by dryness—these regions receive less than 12 inches of precipitation per year. The plants and animals that live in deserts have adapted to survive in extreme conditions.

SUBTROPICAL DESERTS are hot and dry.

POLAR DESERTS are cold all year long.

COASTAL DESERTS have warm summers and cool winters.

JERBOA

RAIN SHADOW DESERTS form on the sides of mountain ranges that block the passage of moist air.

SAHARA DESERT

The Sahara, a subtropical desert in northern Africa, is the world's largest hot desert. It is nearly the size of the continental United States (including Alaska).

ATACAMA DESERT

Chile's coastal Atacama Desert is the driest place on the planet. The region can go decades without any rain at all.

GOBI DESERT

The 500,000 square-mile Gobi Desert, which covers parts of Mongolia and northern China, is a rain shadow desert formed by the Himalayas and the Tibetan Plateau. Its range is expanding into surrounding grasslands due to degradation from the effects of climate change and human activity.

DRY VALLEYS OF ANTARCTICA

The aptly named Dry Valleys of Antarctica have had no rainfall in the past 2 million years. These rocky ecosystems contain frozen lakes of extremely salty water. The largest, Don Juan Pond, is 40 percent saline.

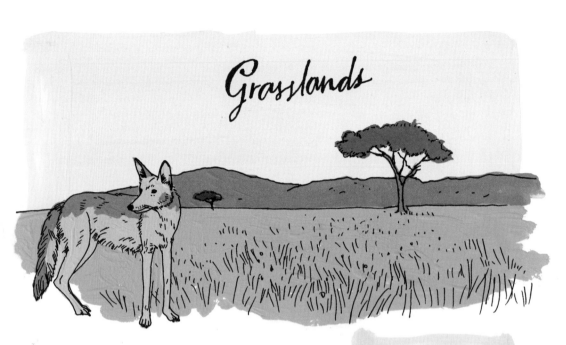

Grasslands

Tropical and temperate grasslands—large areas covered by species of grass with few trees—cover up to 40 percent of the earth's surface. Seasons are generally divided into rainy (growing) and dry (dormant). Rainfall varies from 20 to 35 inches in temperate zones to as much as 60 inches in tropical ones.

In areas with less rainfall, grasses may grow up to a foot. With greater rainfall, some species reach 7 feet tall, with roots that extend 3 to 6 feet underground.

Grasslands support a huge variety of wildlife and plants. Because the soil tends to be rich, these areas also support much of the world's agricultural production. Less than 10 percent of grasslands are protected environments.

BIG BLUESTEM

ROUND-HEADED BUSH CLOVER

PRAIRIE CONEFLOWER

PURPLE PRAIRIE CLOVER

PRAIRIE SMOKE

Wetlands

SWAMPS are forested wetlands that form both inland and along coasts.

COTTONMOUTH

MARSHES are flat, watery grasslands near river mouths, bays, and coastal areas.

BOGS form in colder regions where the water table is high, often developing in depressions carved out by glaciers.

Oceans

The five named oceans—Arctic, Atlantic, Indian, Pacific, Southern—form one giant body of water that covers 71 percent of the earth's surface and produces at least half of the planet's oxygen.

Marine ecosystems include shorelines and hydrothermal vents, coral reefs and polar seas, kelp forests and mangrove swamps. Ecosystems near land are teeming with life, while the abyssal plains at the bottom of the ocean support only a few highly adapted species.

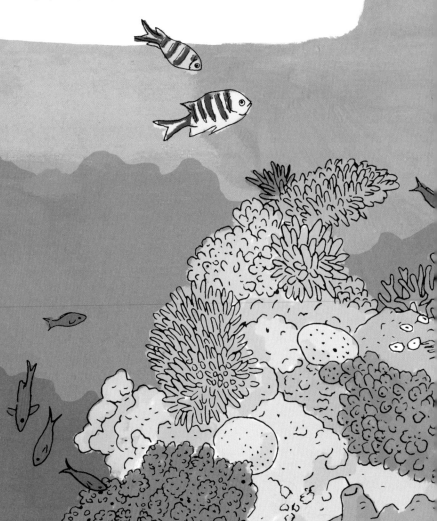

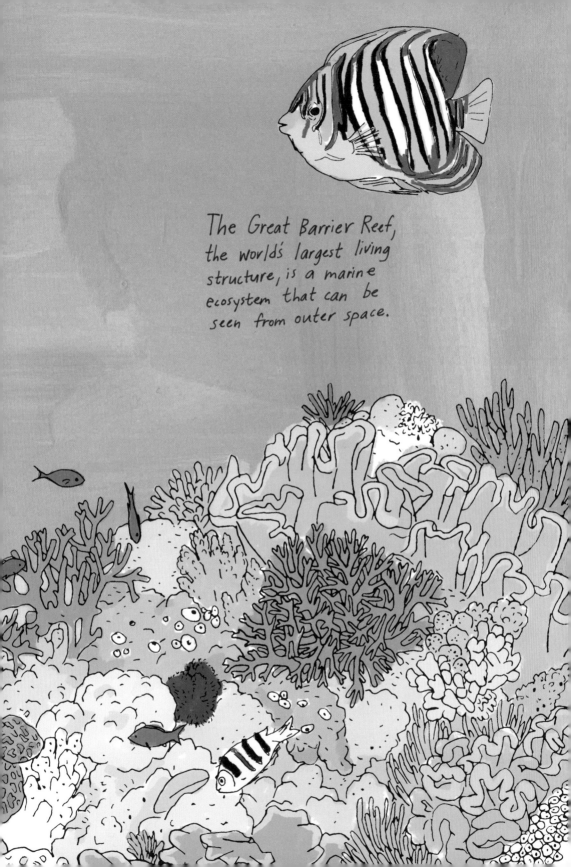

The Great Barrier Reef, the world's largest living structure, is a marine ecosystem that can be seen from outer space.

VERTEBRATES

These are animals that have a backbone.

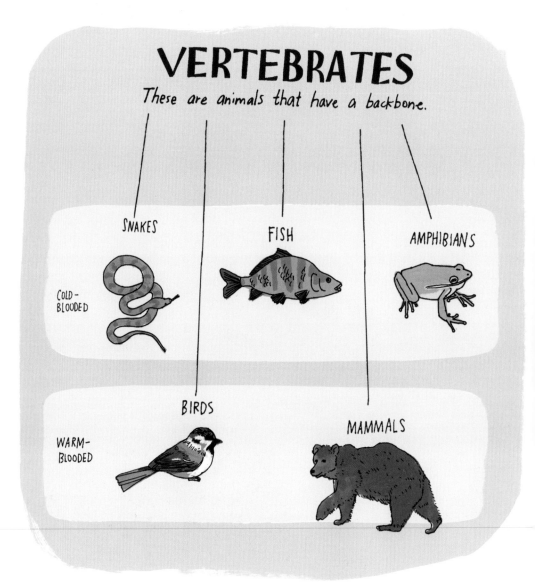

SNAKES

FISH

AMPHIBIANS

COLD-BLOODED

BIRDS

MAMMALS

WARM-BLOODED

INVERTEBRATES

These are animals that do not have a backbone.

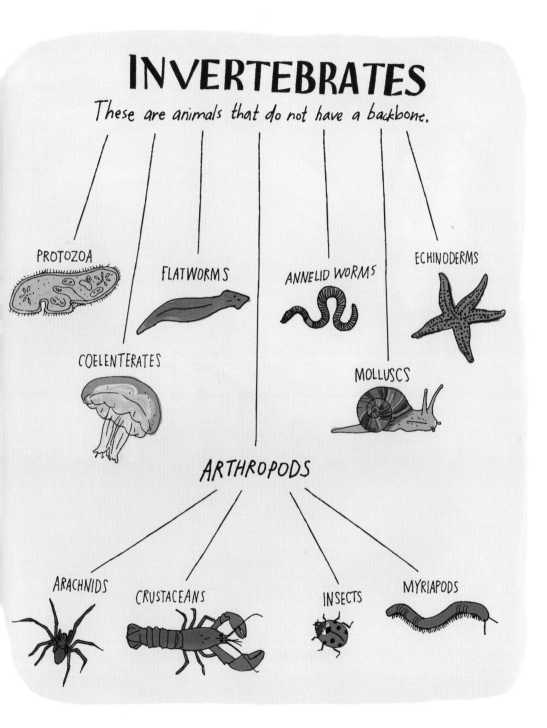

PROTOZOA

FLATWORMS

ANNELID WORMS

ECHINODERMS

COELENTERATES

MOLLUSCS

ARTHROPODS

ARACHNIDS

CRUSTACEANS

INSECTS

MYRIAPODS

A FOOD WEB

TERTIARY CONSUMERS

WILD DOG

HYENA

LION

CHEETAH

SECONDARY CONSUMERS

PANGOLIN

AARDVARK

PRIMARY CONSUMERS

WILDEBEEST

THOMSON'S GAZELLE

GRASSHOPPER

HARVESTER ANT

PRIMARY PRODUCERS

STAR GRASS

RED OAT GRASS

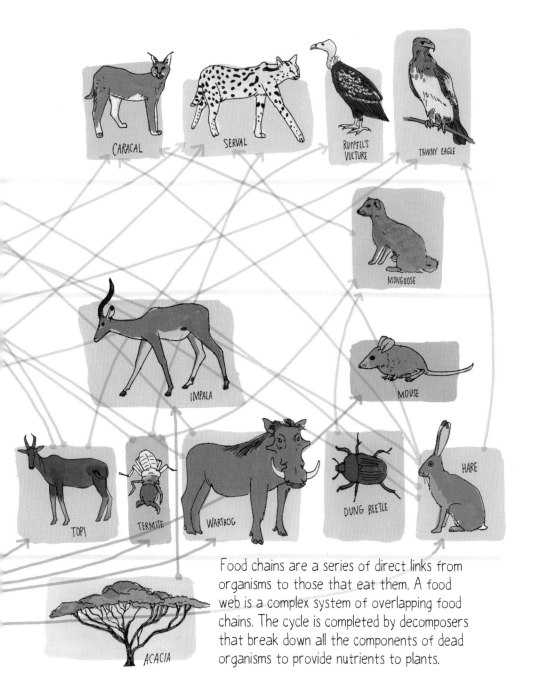

CARACAL

SERVAL

RUPPELL'S VULTURE

TAWNY EAGLE

MONGOOSE

IMPALA

MOUSE

TOPI

TERMITE

WARTHOG

DUNG BEETLE

HARE

ACACIA

Food chains are a series of direct links from organisms to those that eat them. A food web is a complex system of overlapping food chains. The cycle is completed by decomposers that break down all the components of dead organisms to provide nutrients to plants.

TYPES OF EATERS

KOALA

Eucalyptus

HERBIVORES eat plants. Some eat a wide variety; others eat a highly specialized diet. The koala, for example, eats only eucalyptus leaves.

FLYING FOX

Areca fruit

FRUGIVORES eat mostly fruit. Many birds and bats fall in this category.

Grasshopper

PHOEBE

INSECTIVORES specialize in a diet of insects. This group includes many insects, as well as birds, reptiles, fish, and mammals.

STELLER SEA LION

Alaska pollock

CARNIVORES eat other animals. The least weasel, found in many parts of the world, is the smallest carnivorous land mammal. The polar bear is the largest.

WHITE-FACED SAKI MONKEY

OMNIVORES are a large group of animals that eat almost everything. As a feeding strategy, being omnivorous greatly increases the odds of survival.

Dead mouse

MAGGOTS

DETRITIVORES such as worms, fiddler crabs, and dung beetles, break down carcasses and other debris.

GENERALISTS AND SPECIALISTS

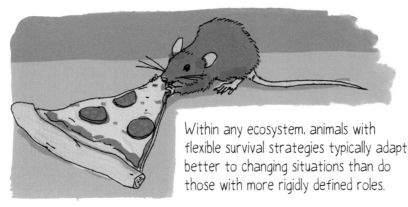

Within any ecosystem, animals with flexible survival strategies typically adapt better to changing situations than do those with more rigidly defined roles.

Adaptable animals such as rats and coyotes are opportunistic feeders with wide-ranging appetites and the ability to change their behavior. Despite decades of eradication efforts, both species thrive in urban areas, often out of sight of their human neighbors.

Other animals have highly specialized diets, even within the same species. Some orca pods, for instance, eat only seals, while others depend on salmon. When stocks of their favored prey are low, they cannot switch to a different food source.

ORCA

SEAL

MARVELOUS MARSUPIALS

Animals have evolved in innumerable ways to survive in nearly every environment on Earth. Some have very specialized body parts for hunting prey or attracting mates. Others have developed peculiar methods of reproducing.

Marsupials have one of the strangest of those strategies. These mammals give birth to still-fetal young that crawl into a pouch where they latch onto a teat and finish developing. This reproductive strategy puts the newborn at great risk but means that the female doesn't have to expend energy carrying a large fetus to term.

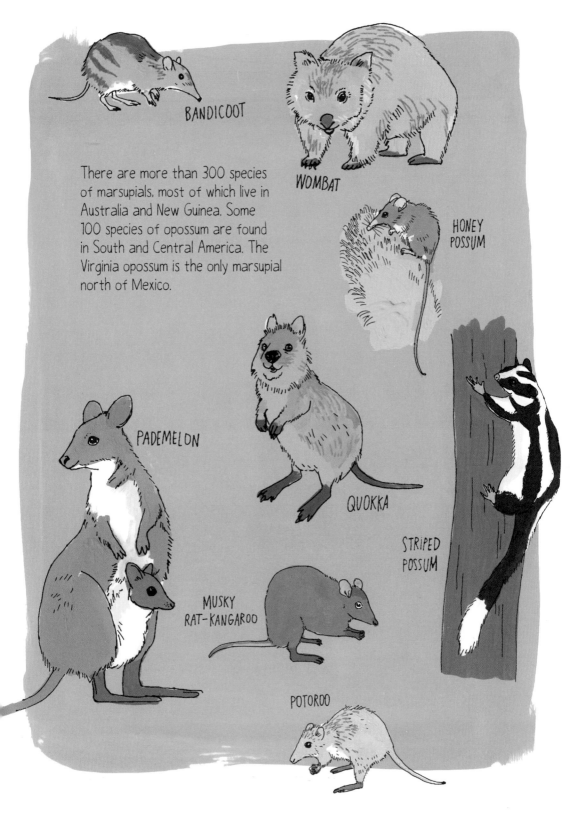

BANDICOOT

WOMBAT

There are more than 300 species of marsupials, most of which live in Australia and New Guinea. Some 100 species of opossum are found in South and Central America. The Virginia opossum is the only marsupial north of Mexico.

HONEY POSSUM

PADEMELON

QUOKKA

STRIPED POSSUM

MUSKY RAT-KANGAROO

POTOROO

Invasion of the Eco-Snatchers

An invasive, non-native, or introduced species is one that is brought into an ecosystem where it has no natural role, and more significantly, no natural predators. In many instances, these plants and animals proliferate unchecked, crowding out or killing off native species. Invasive species may be relocated unintentionally, as with insects that are carried in cargo shipments, but they have very often been released deliberately.

FERAL SWINE

Some 6 million feral swine are found in 35 US states, where they cause an estimated $1.5 billion of damage to agriculture, personal property, and the environment every year.

BURMESE PYTHON

Since first being released into the wild by disenchanted pet owners, Burmese pythons have eaten 90 percent of the small to medium-sized mammals in the Florida.

CANE TOAD

Native to northern South America, Central America, and Mexico, the cane toad was introduced in many countries to control pests in crops such as sugar cane.

Cane toads eat pretty much anything they can catch and compete with native amphibians for habitat. In their native ecosystems, they are kept in check by predators who are immune to the toxic slime they produce, but in other places, animals that try to eat cane toads often wind up dead themselves.

NILE PERCH

This native of northern Africa was introduced in the 1950s to Lake Victoria to boost the fishing economy. One of the largest freshwater fish, it can reach 6 feet in length and weigh as much as 300 pounds.

A voracious eater and breeder, the Nile perch wiped out at least 200 species of other fish within 20 years. Because its flesh is fatty, fishermen must smoke the meat rather than dry it, leading to deforestation around the lake as trees were cut for firewood.

CHAPTER 2

Tooth and Claw

ABOUT TEETH

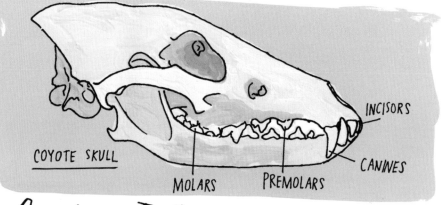

COYOTE SKULL

INCISORS

CANINES

MOLARS PREMOLARS

Carnivore Teeth

Animals that hunt other animals for their meals have specialized teeth for catching prey, tearing into a carcass, and chewing meat and bones. Many carnivores, such as sharks and crocodiles, continuously shed and replace their teeth so they always have a sharp set.

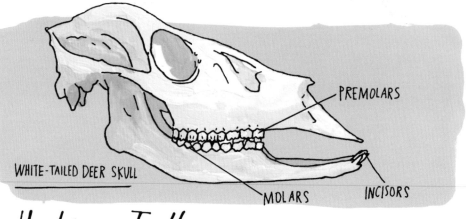

PREMOLARS

WHITE-TAILED DEER SKULL

MOLARS INCISORS

Herbivore Teeth

Animals that eat grasses and other plants have specialized teeth for biting off and chewing plants. Their teeth are worn down by the constant action of grazing. Some rodents and other small mammals have teeth that grow continuously to counteract this.

LOOKS LIKE A LION,
EATS LIKE AN ANTELOPE

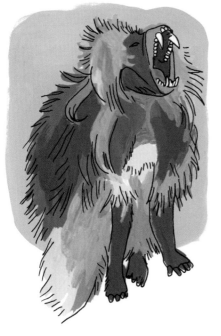

For an animal that eats mostly grasses and leaves, the gelada bears a remarkable resemblance to a lion. Males have a thick mane around their heads, and both sexes have tufted tails and long, sharp canine teeth.

These well-developed canines, shared by all primates other than humans, are for display, not eating. To show aggression, males flip back their upper lip, showing a lot of gum along with their daggerlike teeth.

Geladas live only in the high mountains of Ethiopia. They are sometimes called "the bleeding heart monkey" for the red patches of skin on their chests.

These extremely vocal monkeys live in very large, overlapping social networks comprising small reproductive units that form larger bands. Several bands make up a community, which might include 1,000 individuals.

Geladas have the largest canines for their body size, larger than any other mammal.

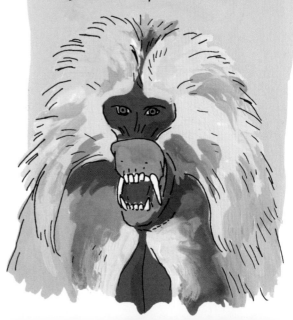

ANATOMY OF A CLAW

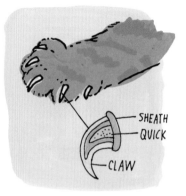

FELINE

Cats, including most wild ones, have claws that they extend for grabbing prey, fending off an attacker, or climbing a tree. Rather than growing in length, feline claws grow in layers, like an onion. As the tips wear down, cats keep their claws in shape by scratching off the ragged outer layer to reveal new sharp points.

SHEATH
QUICK
CLAW

Strictly speaking, feline claws are "protractable," not "retractable." At rest, they are kept retracted by ligaments, which the cat tightens to extend the claws.

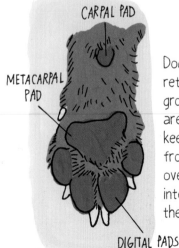

CARPAL PAD

METACARPAL PAD

DIGITAL PADS

CANINE

Dog claws do not retract. As they grow, the tips are worn off, keeping them from getting overly long and interfering with the dog's gait.

Cheetahs have claws that are somewhere in between—they can extend their claws, but unlike other cats, their claws have no protective sheath of skin and they protrude from the paw for extra traction when running.

SOME SPECTACULAR CLAWS

HARPY EAGLE

The harpy eagle has talons nearly 5 inches long for snatching monkeys, sloths, and opossums out of trees.

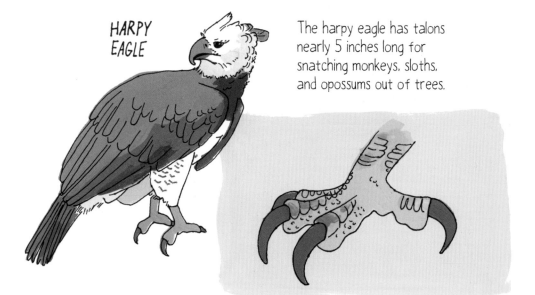

GRIZZLY BEAR

Grizzly bear claws are long (up to 4 inches) and straight, for catching fish, digging up roots or wasps' nests, and breaking apart rotting trees.

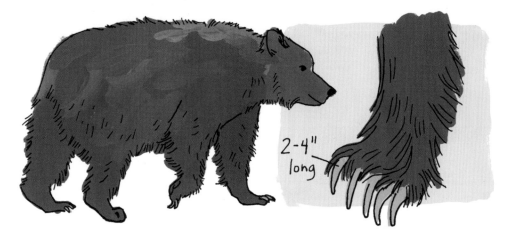

2-4" long

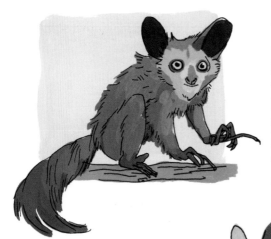

AYE-AYE

The aye-aye, a long-fingered lemur from Madagascar, uses its peculiarly long middle finger to tap on trees to find grubs. When it locates some, it gnaws into the wood with its protruding, rodent-like teeth, then stabs its prey and pulls it out with the sharp claw on the tip of the same finger.

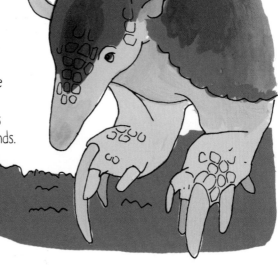

GIANT ARMADILLO

The giant armadillo's massive middle claws are perfectly adapted for digging burrows and tearing up termite mounds.

SNAPPING SHRIMP

The snapping shrimp snaps its enlarged claw hard and fast enough to create a shockwave that stuns nearby prey. The force of the snap creates not only a sharp sound, but a flash of light!

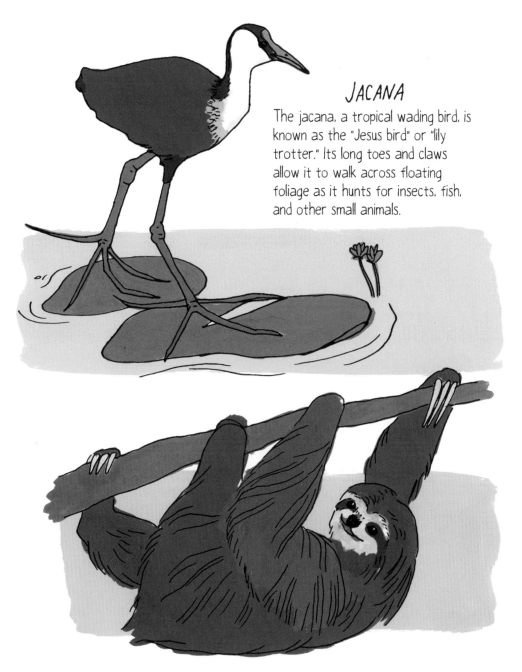

JACANA

The jacana, a tropical wading bird, is known as the "Jesus bird" or "lily trotter." Its long toes and claws allow it to walk across floating foliage as it hunts for insects, fish, and other small animals.

THREE-TOED SLOTH

Two- and three-toed sloths use their long claws and strong forearms to hang from tree branches. Their hind legs are so weak that they can barely walk on land.

HUNTING TACTICS

Many predators, both individually and in packs, pursue and pounce on their prey. Others have developed more unusual methods.

BLOWING BUBBLES

Humpback whales gather in circles to create bubble nets around schools of fish, trapping and disorienting them. They then swim up through the crowd of fish, swallowing huge mouthfuls.

THROWING A NET

The net-casting spider of Australia spins a small web to capture insects. It drops white feces as a target, then hangs overhead from two legs, holding the net in its four front legs. When an insect crosses the target, the spider drops down to trap it.

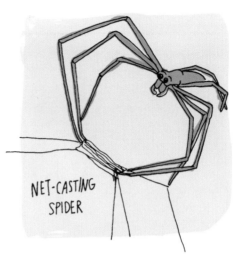

NET-CASTING SPIDER

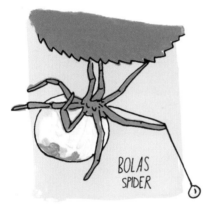

BOLAS SPIDER

LASSOING

Instead of a net, the bolas spider spins a length of silk with a sticky blob at the end. Using pheromones to mimic the scent of female moths, they lure unsuspecting male moths close enough to snare them.

MAKING DECOY CALLS

The margay, a small South American wild cat, has been observed imitating the cry of an infant pied tamarin to attract adults within striking range.

USING LURES

The cantil, a pit viper, is one of several species of snakes that waggle the ends of their tails like worms.

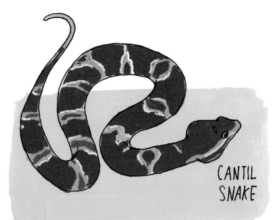

CANTIL SNAKE

The wobbegong, an Australian shark, waves its tail languidly to resemble a fish.

WOBBEGONG

Alligator snapping turtles have fleshy appendages in their mouths that they wiggle to attract prey.

ALLIGATOR SNAPPING TURTLE

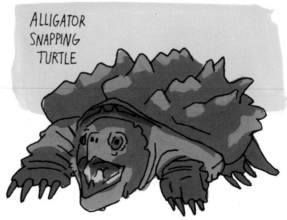

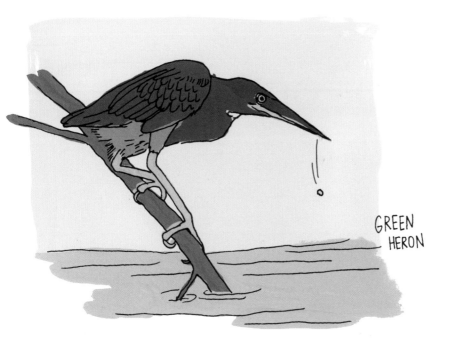

GREEN
HERON

USING BAIT

Green herons drop small items, including sticks, insects, and pieces of bread, into the water to attract fish to the surface.

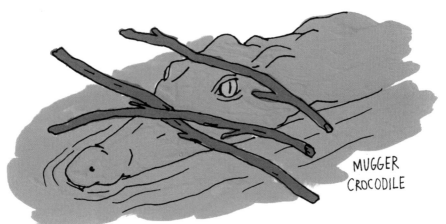

MUGGER
CROCODILE

BAIT & SWITCH

Mugger crocodiles in India sometimes lie hidden in shallow water with sticks covering their snouts. When birds looking for nesting materials investigate the sticks, the croc lunges.

PRIDE OF PLACE

The so-called King of the Jungle lives mostly in grasslands, and the females do most of the hunting, so Queen of the Savannah might be a more appropriate nickname. The only large cats that live in social groups, lions live in prides ranging in size from a few individuals to as many as 40.

All the females in a pride are related. They bear their litters at roughly the same time and raise the cubs communally, with some hunting and others watching the cubs. Males defend the pride's territory by roaring and sometimes fighting off rival males.

Although they hunt in a group—the only cats that do so—lions aren't particularly efficient hunters. They can run 35 mph but not for long and only if they don't have to turn, so they must sneak close to their prey before attacking. After the females bring down their prey, the males move in to eat first. Cubs eat last; in lean times, they may starve.

A lion's roar can be heard up to 5 miles away.

Lions and hyenas occupy much the same niche and have an adversarial relationship. The old stereotype of the mighty lion hunter and the slinking hyena scavenger has been upended. Researchers report that in many cases, spotted hyenas are driven off a successful kill by lions who move in to take over the carcass.

Where lions used to live historically

Where lions live now

Lions used to roam over most of Africa but have disappeared from 94 percent of their former range. Competition with humans for prey, threats from poaching and poisoning, and loss of habitat have caused lion numbers to fall by more than 40 percent in the past 20 years.

Redrawn from Panthera.org

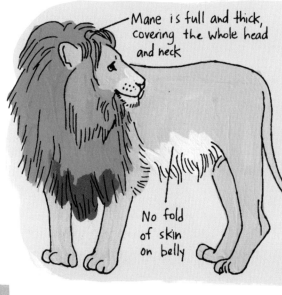

Mane is sparse, short, and dark, with ears showing

- Found only in Gir National Park, Gujarat, India
- Highly endangered— only 600 or so left
- Hunts smaller prey, primarily chital deer

Has a fold of skin running along the belly

Tail and elbow tufts are more pronounced

Pride = 1 male and 2 or 3 females

ASIATIC LION
vs.
AFRICAN LION

Mane is full and thick, covering the whole head and neck

- Lives mostly in East and Southern Africa
- Vulnerable — fewer than 40,000 remain
- Hunts larger prey; zebra, wildebeest, and cape buffalo

No fold of skin on belly

Tail and elbow tufts less pronounced

Pride = 2 or more males, 6 or more females

THE MISUNDERSTOOD HYENA

For centuries, hyenas have had a bad reputation, but these highly social and intelligent animals deserve better press. Widely regarded as primarily scavengers, hyenas are also proficient hunters, both solo and in packs. They do play an important role as scavengers, eating every bit of a carcass. Their massively strong jaws shatter bone, which they digest in their highly acidic stomachs.

There are four quite distinct species of hyena—spotted, striped, brown, and the aardwolf—distributed throughout Africa and parts of Asia. More closely related to felines than canines, they form their own family: Hyaenidae.

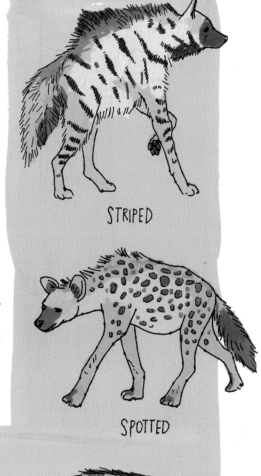

STRIPED

SPOTTED

BROWN

AARDWOLF

APEX PREDATORS

In many ecosystems, the food chain leads to an apex predator, one that eats other animals but has no natural enemies that prey on it.

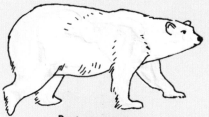

POLAR BEAR
The largest land-based carnivore

ORCA
Capable of killing and eating great white sharks

TIGER
Has the biggest canine teeth of any cat (3–4 inches)

GOLDEN EAGLE
Dives at 150 mph to grab prey— sometimes even as large as itself

SALTWATER CROCODILE
17 feet long, weighs 1,000 pounds, can swim 18 mph

KOMODO DRAGON
Up to 10 feet long and more than 300 pounds; has a venomous bite

WHEN IS A PANTHER
NOT A PANTHER?

The genus *Panthera* contains four species: lions, tigers, jaguars, and leopards. The word "panther" can refer to different animals, depending on where you are. In much of the world, it means a leopard; in Latin America, it typically means a jaguar.

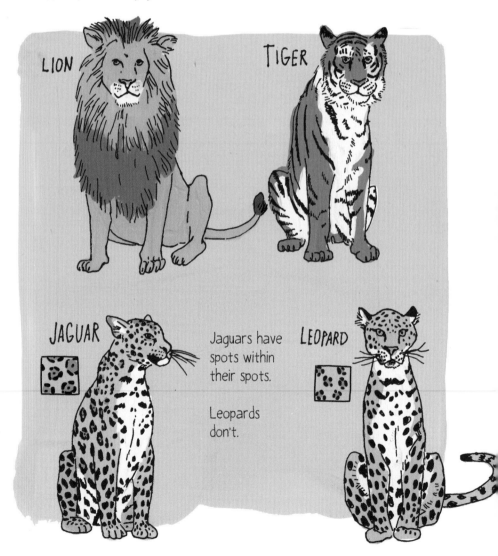

LION

TIGER

JAGUAR

Jaguars have spots within their spots.

Leopards don't.

LEOPARD

In North America, "panther" generally means a mountain lion, also called a puma, cougar, or catamount. The mountain lion is in the genus *Puma* and technically isn't a panther at all.

Mountain lions once roamed all over the Americas but their range has been drastically reduced. They are considered extinct in most of the eastern United States, though sightings are reported. The Florida panther, a subspecies, is endangered, with fewer than 200 individuals remaining.

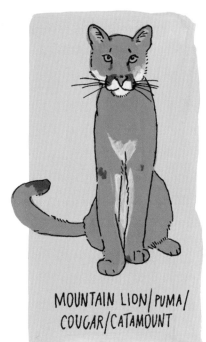

MOUNTAIN LION/PUMA/
COUGAR/CATAMOUNT

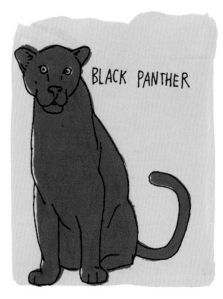

BLACK PANTHER

Black panthers—which are always jaguars or leopards—still have spots. Their coloring comes from an overabundance of melanin or dark pigment in their fur.

Lions, tigers, jaguars, and leopards are the only large cats that roar. Pumas scream instead.

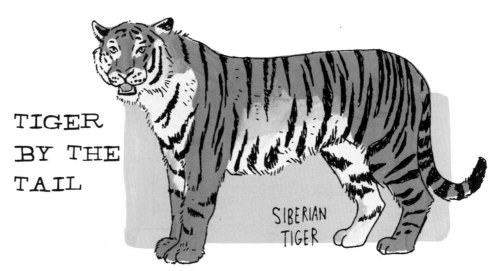

TIGER BY THE TAIL

SIBERIAN TIGER

Of the six subspecies of tiger, the Siberian is the largest, weighing in at over 600 pounds and measuring up to 12 feet from nose to tail. The Bengal tiger, which accounts for about half the world's population of tigers, weighs about 450 pounds and measures 9 to 10 feet. Females are smaller.

White tigers are a rare genetic variant of Bengal tiger.

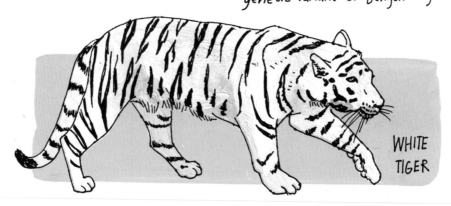

WHITE TIGER

Whether white or orange, every tiger's stripe pattern is unique.

Tigers have webbed toes and are excellent swimmers who seem to like being in water.

The Charming Cheetah

Although considered one of the big cats, the long and lanky cheetah weighs at most about 140 pounds. With its keen eyesight and incredible speed (60+ mph), the cheetah hunts during the day, partly to avoid competing with lions.

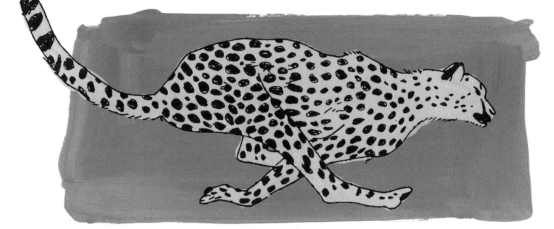

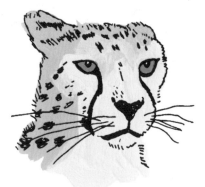

Cheetahs bark, purr, chirp, and growl, but they do not roar.

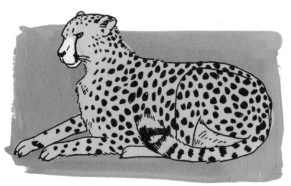

The "tear marks" on the cheetah's face serve to cut down on glare from the sun.

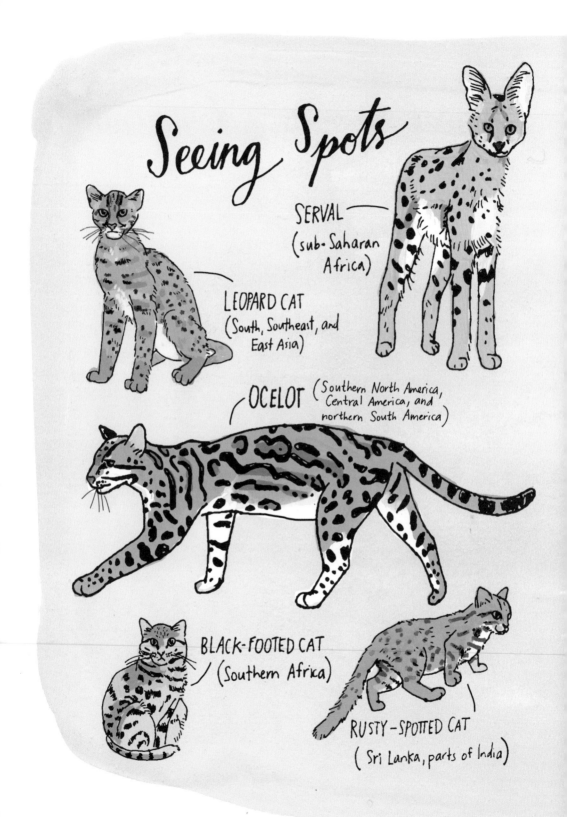

Seeing Spots

SERVAL
(sub-Saharan Africa)

LEOPARD CAT
(South, Southeast, and East Asia)

OCELOT (Southern North America, Central America, and northern South America)

BLACK-FOOTED CAT
(Southern Africa)

RUSTY-SPOTTED CAT
(Sri Lanka, parts of India)

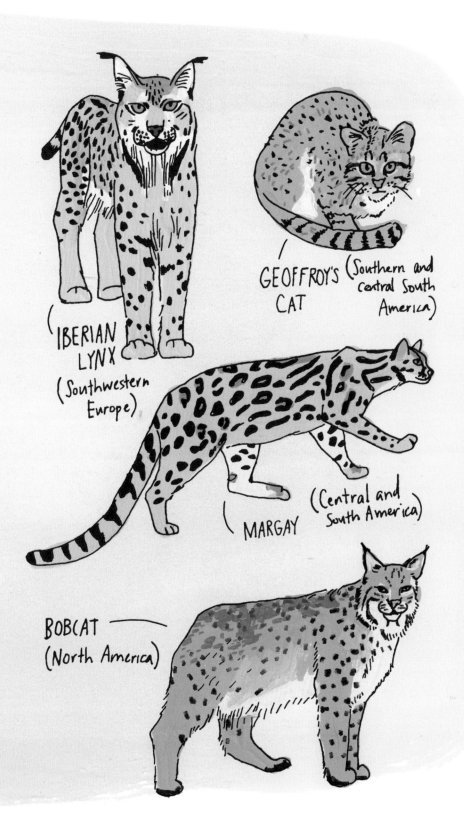

IBERIAN
LYNX
(Southwestern
Europe)

GEOFFROY'S
CAT (Southern and
central South
America)

MARGAY (Central and
South America)

BOBCAT
(North America)

Jaguarundi

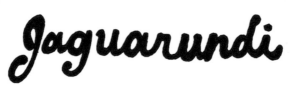

With its flattened head, small ears, long body, and short legs, the jaguarundi somewhat resembles a small otter. Its short, thick coat comes in red and gray. Both colors can appear in the same litter. It is one of the only wild felines that doesn't have a contrasting color on the back of the ear.

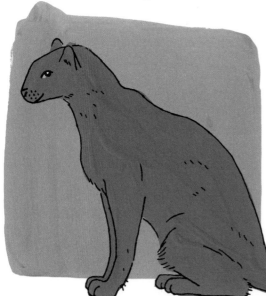

This cousin of the cougar ranges through much of Central and South America. Though an excellent climber, it is mostly terrestrial, hunting rodents, birds, and reptiles. More active during the day than most wild cats, it is often observed in pairs.

The jaguarundi has a remarkable vocabulary for a feline, with at least 13 distinct calls that include purring, chattering, and chirping.

Fossa

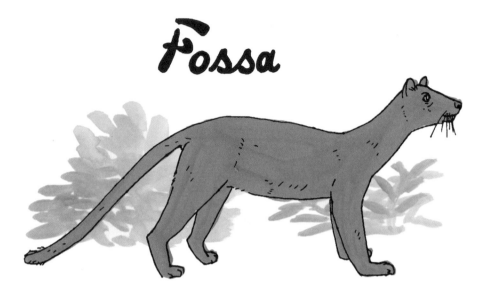

Cat? Dog? Mongoose? It may not look like the stereotypical "king of the jungle," but the fossa (pronounced FOO-sa) is the top predator in Madagascar. This relative of the mongoose and the civet will eat anything it can catch, though its favorite prey is lemurs.

The fossa is nearly 6 feet long, with the tail making up half that length. With its tail for balance and a set of sharp claws for gripping, the fossa is an agile leaper and climber, equally at home in treetops and on the ground.

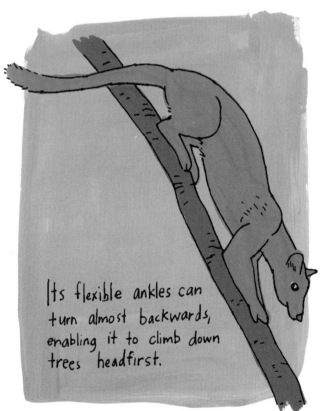

Its flexible ankles can turn almost backwards, enabling it to climb down trees headfirst.

BEARS OF THE WORLD

POLAR BEAR

- Largest land predator in the world
- Skin is black; fur is translucent, not white
- Can eat 150 pounds at once, then go days without food

GRIZZLY BEAR

- Lives in forest, tundra, mountain, and even desert terrain
- Can run 30 mph
- Eats ravenously in fall and loses one-third of its body weight during winter hibernation

BLACK BEAR

- Comes in several colors, including blond, red, and several shades of brown
- Makes a variety of sounds, from squeals and grunts to a humming "purr" when content
- Leaves scent markings by rubbing its back against trees, and scratching and biting the bark

SPECTACLED BEAR

- Mostly arboreal, even sleeping in trees
- Eats primarily plants, especially bromeliads, but also insects and small animals
- Each bear has unique markings

GIANT PANDA

- Can chew bamboo shoots that would break a woodchipper
- Curious and playful; likes to somersault
- Very rarely, a brown and white panda will be born

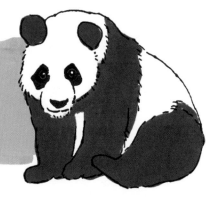

SUNBEAR

- Also called the dog bear or honey bear
- Nocturnal, despite its name
- Adept at climbing; spends a lot of time in trees

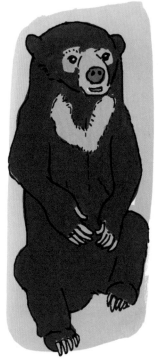

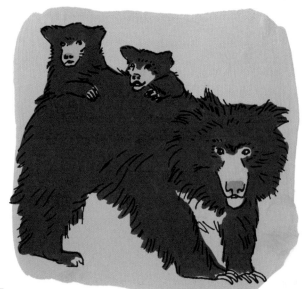

SLOTH BEAR

- So called because it was once thought to be related to sloths
- Eats mostly termites and ants, some fruit
- Mothers carry their cubs on their back, the only bear to do so

MOON BEAR

- Spends a lot of time in trees
- Often stands and even walks upright
- Also known as the Asian black bear

NOT A BEAR: THE WOLVERINE

It looks like a small bear, but the wolverine is the largest terrestrial member of the Mustelidae family, which includes otters, weasels, and skunks. Though it eats some vegetation, the solitary wolverine is a fierce hunter that is known to tackle prey many times its own size if it can seize the advantage. It will eat carrion and dig out a den to get at a hibernating animal.

Its teeth and jaws are powerful enough to crush and chew bones.

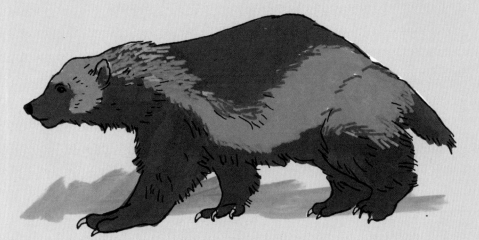

Weight: 24–40 pounds Length: 33–44 inches including tail

Baby wolverines, called kits, are born white.

ANIMALS THAT FISH FOR THEIR SUPPER

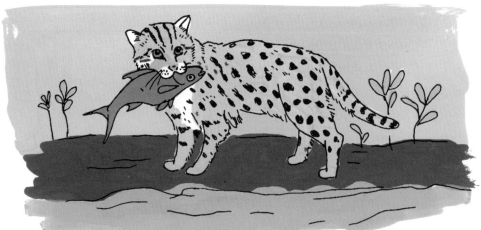

FISHING CAT
- Lives in south and southeast Asia
- Fish make up three-quarters of its diet
- A proficient swimmer, even underwater
- About twice the size of a domestic cat

Can consume up to 30 fish a night

FISHING BAT
- Lives in Central and South America
- Uses echolocation to pinpoint fish near the surface
- Swoops down and grabs them with its long-toed, sharp-clawed feet
- Guano changes color depending on its diet: black for fish, red for crustaceans, brown and green for algae and insects

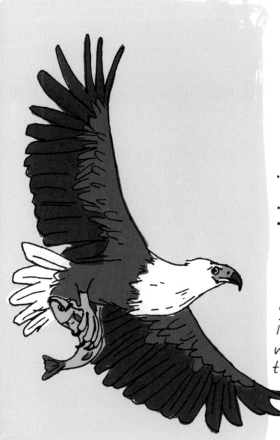

AFRICAN FISH EAGLE

- Hunts primarily by lakes and river mouths
- Also preys on waterfowl
- Wingspan can be up to 8 feet (females); 6½ feet (males)

If a fish eagle catches a fish too heavy to carry, it sometimes drops into the water and paddles its prey to shore with its wings.

Fish That Hunt Out of Water

The archerfish spits blobs of water at insects to knock them into the water, and the arowana can jump 6 feet out of the water to snatch insects and small birds from overhanging branches.

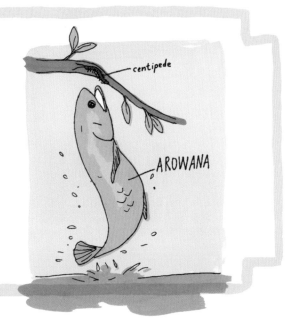

centipede

AROWANA

A DIFFERENT KIND OF FISHER

Despite its name, the fisher, often called a fisher cat, doesn't eat fish and isn't a feline. A medium-sized member of the Mustelidae family, the fisher lives in Canada and the northern United States. It preys mainly on hares and other small animals but doesn't hesitate to take on larger animals, including lynxes.

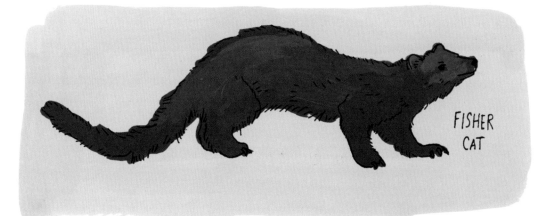

FISHER CAT

The fisher is one of very few predators that routinely kills porcupines, which it does by attacking the head until the porcupine is disoriented, then flipping it over to tear into the belly.

SMALL BUT MIGHTY

SHORT-TAILED SHREW

Short-tailed shrews are the only animals in North America with venomous saliva. They prey on insects, small lizards and salamanders, snakes, and mice.

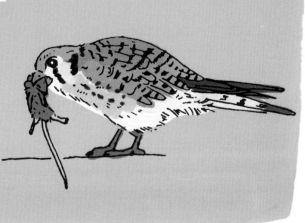

LEAST WEASEL

Least weasels, one of the smallest carnivores in the world, mainly hunt small rodents but can kill rabbits many times larger than they are.

AMERICAN KESTREL

The beautiful American kestrel is the smallest falcon in North America. Even smaller is the sparrow-sized falconet, found in the Indian subcontinent and Southeast Asia.

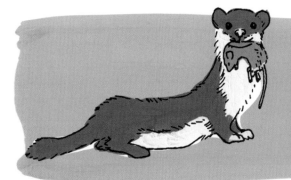

ANATOMY OF A TARANTULA

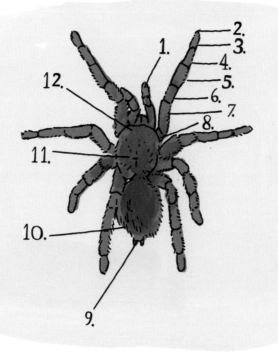

1. pedipalp
2. tarsal claw
3. tarsus
4. metatarsus
5. tibia
6. patella
7. femur
8. trochanter
9. spinnerets
10. urticating hairs
11. carapace
12. eyes

LARGE AND HAIRY

The biggest spiders in the world, tarantulas are found in warm areas on nearly every continent. Most of the hundreds of species of tarantulas are native to South America.

Rather than making webs, these nocturnal hunters stalk and capture their prey, killing them with a venomous bite. They eat a variety of insects, as well as larger prey such as mice, snakes, and frogs.

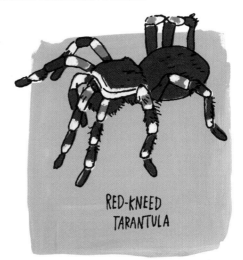

RED-KNEED
TARANTULA

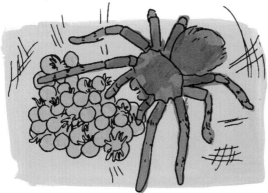

Most males die soon after mating, but females can live for 25 years. They lay up to 1,000 eggs at a time and stand guard for six to nine weeks until the eggs hatch.

The tarantula hawk is a large parasitic wasp that paralyzes a tarantula with venom, then lays a single egg in its body. When it hatches, the larva eats the still-living victim.

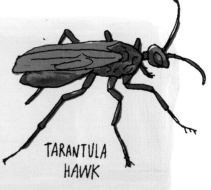

TARANTULA
HAWK

BIG FISH WITH BIG TEETH

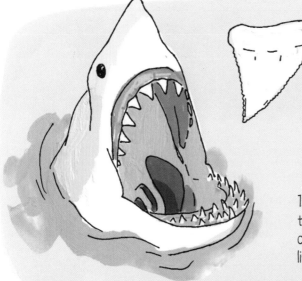

GREAT WHITE SHARK

15-16 feet long; has up to 300 teeth arranged in rows that it can replace throughout its lifetime

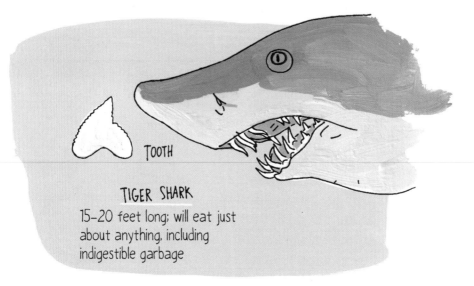

TOOTH

TIGER SHARK

15-20 feet long; will eat just about anything, including indigestible garbage

MORAY EEL

Some species reach 10–12 feet;
a second set of teeth on the eel's
pharyngeal jaw is used to grab and
swallow prey

PHARYNGEAL JAW

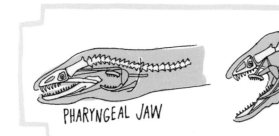

GREAT BARRACUDA

Up to 10 feet long;
hunts by sight and kills
smaller fish by biting
them in half

SAWFISH

Up to 20 feet long; uses its
toothy rostrum to detect the
weak electrical fields produced
by nearby prey

THE EYES OF EAGLES

CROWNED EAGLE
A powerful African predator, it can kill animals more than four times its size.

STELLER'S SEA EAGLE
This huge bird can weigh up to 20 pounds and has a wingspan of 8 feet. It eats mostly salmon. Found in Japan and parts of Russia, it is considered vulnerable.

WEDGE-TAILED EAGLE
Australia's largest bird of prey can soar for more than an hour without a wingbeat.

PHILIPPINE EAGLE

Also known as the monkey-eating eagle, this critically endangered bird lives only on four forested islands in the Philippines.

In most raptor species, the female is larger than the male.

BATELEUR

Found in many parts of Africa, the bateleur is unusual among raptors in that males and females have different plumage, making it easy to tell them apart.

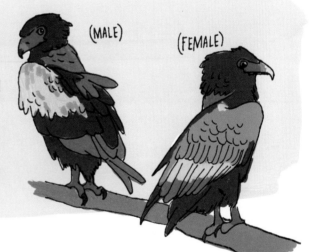

(MALE) (FEMALE)

MARTIAL EAGLE

The largest eagle in Africa and one of the most powerful avian predators, these opportunistic hunters can spot prey from over 3 miles away.

ANATOMY OF AN OWL

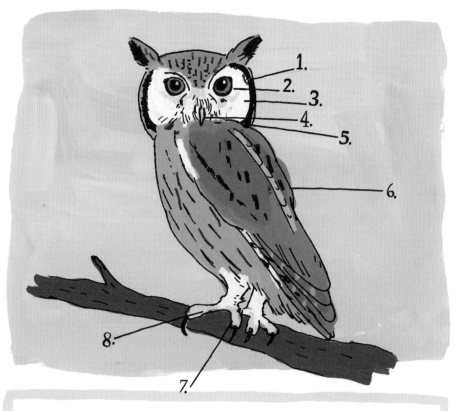

1. ears — some species have offset ears for pinpointing sounds more accurately

2. eyes — tubular, do not move within the socket, can occupy up to 40 percent of the skull

3. facial disk — stiff feathers around the face that direct sound to the ears

4. beak — sharp and pointed for tearing apart prey

5. neck bones — 14, allowing for 270-degree rotation of the head

6. feathers — fringed for silent flight (not all owls)

7. talons — hooked claws for catching prey

8. zygodactyl feet — 2 toes face forward, 2 face backward

BLAKISTON'S FISH OWL

One of the largest owls, it stands 3 feet tall and has a wingspan of nearly 6 feet. It hunts fish and frogs along riverbanks in the few places in Japan and Russia where it is found.

SPECTACLED OWL

Native to Mexico, Central America, and northern South America, this owl is named for its distinctive facial markings.

Owlets have black spectacles on white; in adults the coloring is reversed.

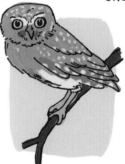

SPECTACLED OWLET

ELF OWL

The size of a sparrow, this tiny raptor feeds on insects. It lives in desert areas in the southwestern United States and Mexico.

NORTHERN HAWK OWL

A superb flyer, the northern hawk owl hunts mostly rodents but can take smaller birds in midair. It can be found in boreal forests from Alaska to Russia.

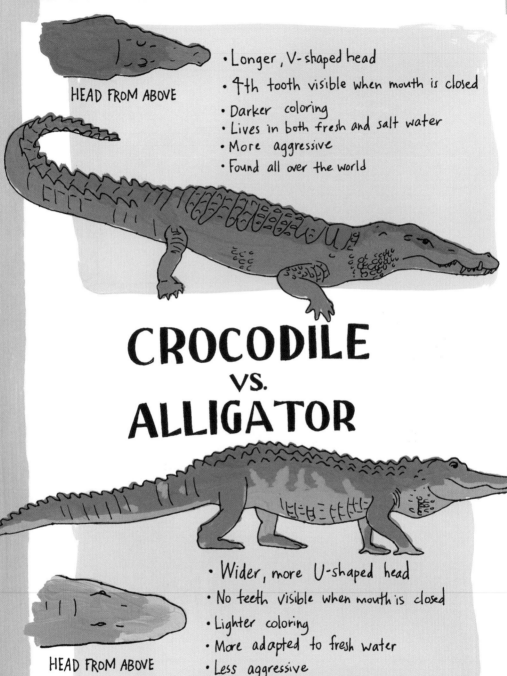

- Longer, V-shaped head
- 4th tooth visible when mouth is closed
- Darker coloring
- Lives in both fresh and salt water
- More aggressive
- Found all over the world

HEAD FROM ABOVE

CROCODILE
VS.
ALLIGATOR

- Wider, more U-shaped head
- No teeth visible when mouth is closed
- Lighter coloring
- More adapted to fresh water
- Less aggressive
- Found only in United States and China

HEAD FROM ABOVE

Crocodiles try to keep their body temperature between 86 and 91°F (30–33°C) either by basking in the sun or finding shade. When sunning itself, a crocodile may "gape" its mouth to keep its brain cool while the rest of its body heats up.

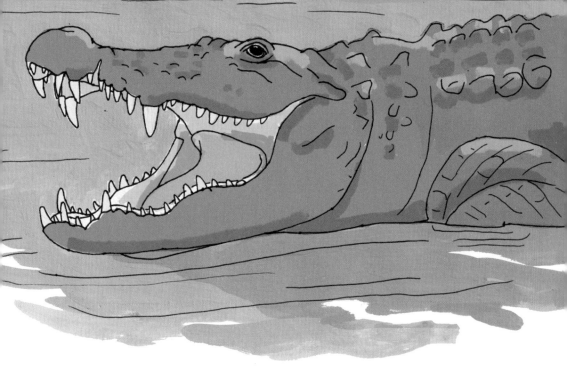

Killer Lizards

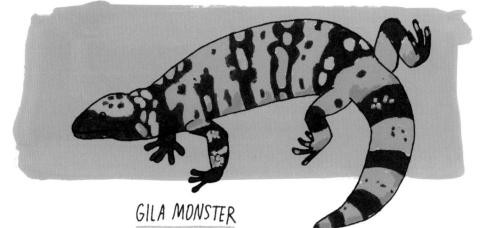

GILA MONSTER

The largest lizard native to the United States, the gila (HEE-la) monster is one of the few species of venomous lizards. Rather than injecting venom, it grabs its victim and chews to force neurotoxins into the wound through grooves in its teeth.

Weighing as much as 5 pounds and reaching up to 2 feet long, gilas can store fat in their tails and go months without eating.

BEADED LIZARD

These venomous lizards, found in Mexico and southern Guatemala, are covered in small, beadlike scales. They spend most of the day in burrows, emerging at night to climb trees in search of birds, reptiles, and other small prey.

PERENTIE

Native to Australia, perenties are solitary hunters who use their long, strong tails to strike at and disable their prey before shaking it to death and swallowing it whole.

KOMODO DRAGON

These massive lizards, found only on a few Indonesian islands, can eat as much as 80 percent of their body weight at a time. They will lighten their load by vomiting before fleeing from a threat or fighting during mating season.

A WAKE OF VULTURES

Carrion eaters play a vital role in every ecosystem by clearing away the remains of rotting carcasses and helping limit the spread of disease. There are 23 species of vultures spread around the world—the only places they don't live are Australia and Antarctica.

Most vultures are spectacular aerialists, using air currents to rise high above ground and staying aloft for hours with very little effort. Some hunt by sight, watching to see where predators have made a kill or other vultures are gathering. Most also have a keen sense of smell that helps them locate dead animals.

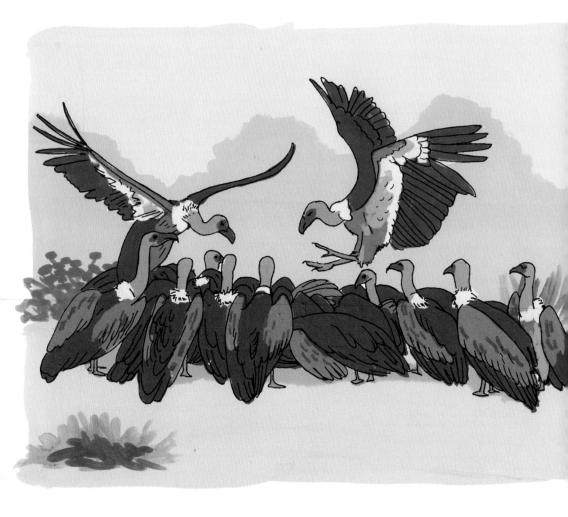

LAPPET-FACED VULTURE

The largest of the African vultures, this species gets its common name from the fleshy folds of skin on the side of its neck. Like many other carrion-eating birds, they are threatened by habitat loss and human predation, and often die from eating poisoned meat.

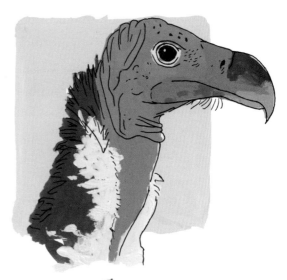

TURKEY VULTURE

Solitary by day, turkey vultures congregate at night in large roosts of 30 or more birds. Also known as the turkey buzzard, this is the most widespread vulture in North America. Females lay their eggs in caves or on the ground. Both parents incubate the eggs and care for the young.

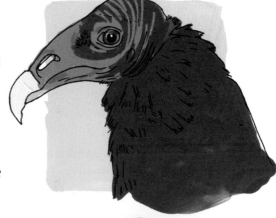

KING VULTURE

The king vulture's colorful head is set off by its striking black and white plumage. Ranging from the south of Mexico down to northern Argentina, king vultures mate for life. Often first to arrive at a carcass, they have relatively weak beaks and will eat the eyes of a kill while waiting for stronger birds to tear into the hide.

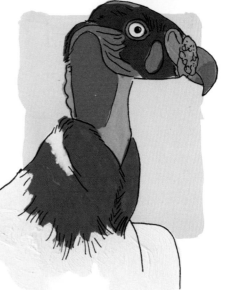

CHAPTER 3

Have You Herd?

- Eyes on front of face for focusing on fleeing prey
- Vertical or round pupils for judging depth of field and distance
- Better binocular vision

PREDATOR vs. PREY

Whether an animal is among the hunted or the hunters plays a part in where its eyes are located. An old saying goes, "Eyes on the side, born to hide; eyes on the front, born to hunt."

- Eyes widely spaced for better peripheral vision
- Horizontal pupils allow for a more panoramic view
- Point of focus changes as head moves up and down

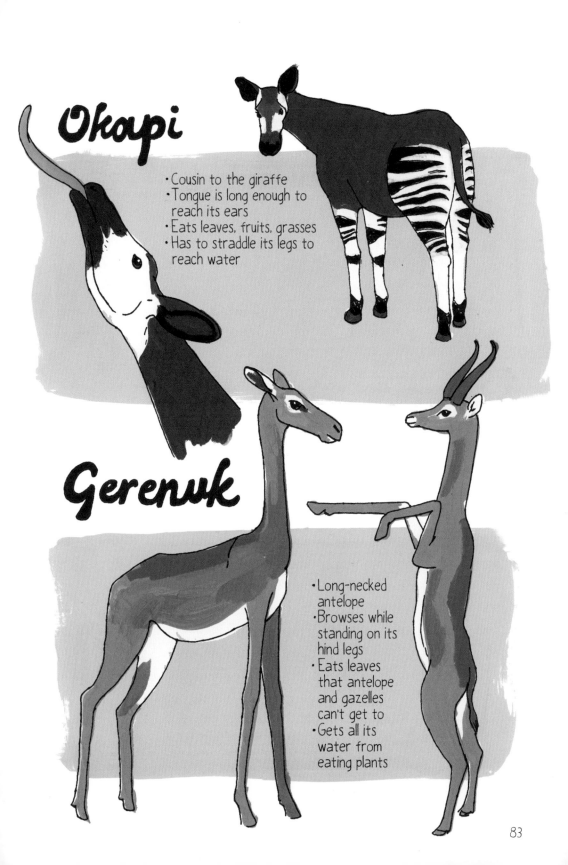

Okapi

- Cousin to the giraffe
- Tongue is long enough to reach its ears
- Eats leaves, fruits, grasses
- Has to straddle its legs to reach water

Gerenuk

- Long-necked antelope
- Browses while standing on its hind legs
- Eats leaves that antelope and gazelles can't get to
- Gets all its water from eating plants

ANATOMY OF A GIRAFFE

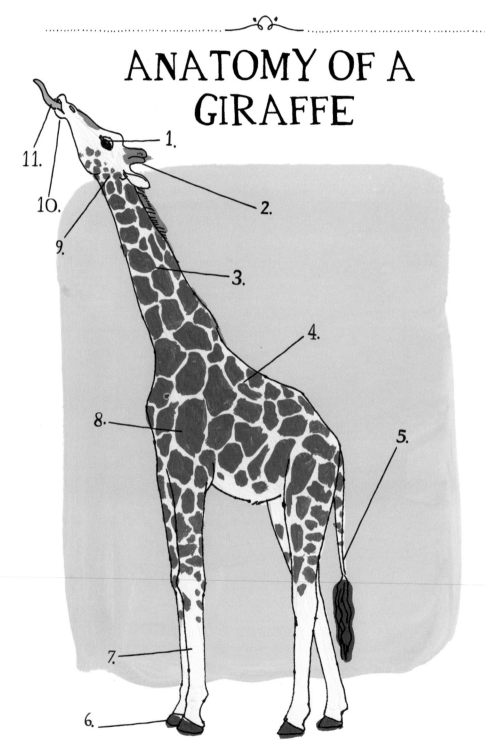

1.

2.

3.

4.

5.

6.

7.

8.

9.

10.

11.

1. **eyes** able to see their feet and a few meters ahead simultaneously

2. **ossicones** horns covered in skin and fur; both males and females have them

3. **neck** just 7 bones, each up to 10 inches long
 ball-and-socket connection of neck bones gives great flexibility
 massive ligaments provide support to neck muscles
 specialized arteries regulate blood flow to the head

4. **color pattern** darker patches release heat via clusters of sweat glands
 and blood vessels

5. **tail** long tassel for swatting insects

6. **hooves** two-toed hooves are about 12 inches in diameter

7. **shins** tight skin helps regulate blood pressure

8. **heart** weighs 24 pounds and beats 60–90 times per minute

9. **neck joint** allows the head to reach nearly vertically when feeding

10. **lips** mobile and sensitive for nibbling leaves

11. **tongue** 18 inches long and black to protect against sunburn

A giraffe pregnancy lasts
14 to 15 months and produces
a 100- to 150-pound, 6-foot
tall calf that can run faster
than its mother within a
few hours of birth.

Giraffes eat primarily acacia leaves, stripping them from among the thorns with their prehensile 18-inch-long tongues and mobile lips. They also lick and nibble bones and antlers from carcasses to get calcium, phosphorus, and other nutrients that aren't available from their vegetarian diet.

Living in groups of 10 to 20 animals, adult giraffes have no natural predators other than lions and crocodiles. Threats from humans, however, have have left two of Africa's four species of giraffes in danger of extinction.

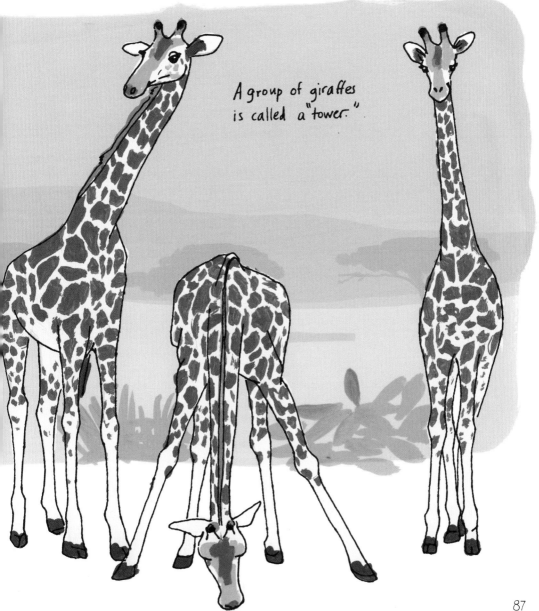

A group of giraffes is called a "tower."

HORNS

Horns have a bony core covered with keratin (the same material fingernails are made of). They are a permanent extension of the skull and can be found on both male and female members of many bovids (cow, sheep, goats, antelopes). Horns grow larger as the animal ages.

A boss is a bony plate on the forehead where the horns meet.

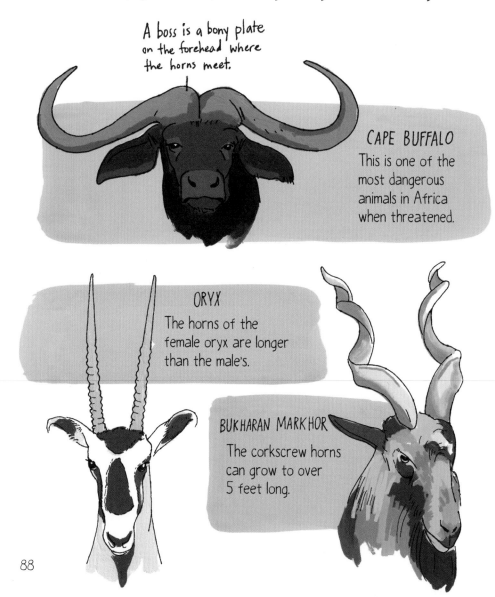

CAPE BUFFALO
This is one of the most dangerous animals in Africa when threatened.

ORYX
The horns of the female oryx are longer than the male's.

BUKHARAN MARKHOR
The corkscrew horns can grow to over 5 feet long.

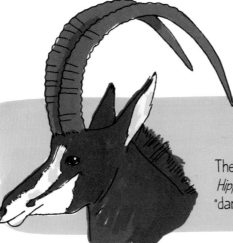

SABLE ANTELOPE

The scientific name, *Hippotragus niger,* means "dark, goatlike horse."

SPRINGBOK

Leaping into the air with all four hooves off the ground is a common behavior among springbok and some other antelope species. Called "pronking," or "stotting," it may occur during pursuit by a predator but is also a playful action.

IBEX

Ibex hooves act almost like suction cups, enabling the animals to climb nearly vertical surfaces, like the face of the Cingino Dam in the Italian Alps.

SPECTACULAR ANTLERS

Antlers are made of cartilage that hardens into bone. While growing, they are covered with "velvet," a skin that brings blood to the growing structure. Antlers, which are grown and shed every year, are found almost exclusively on males in the cervid (deer) family.

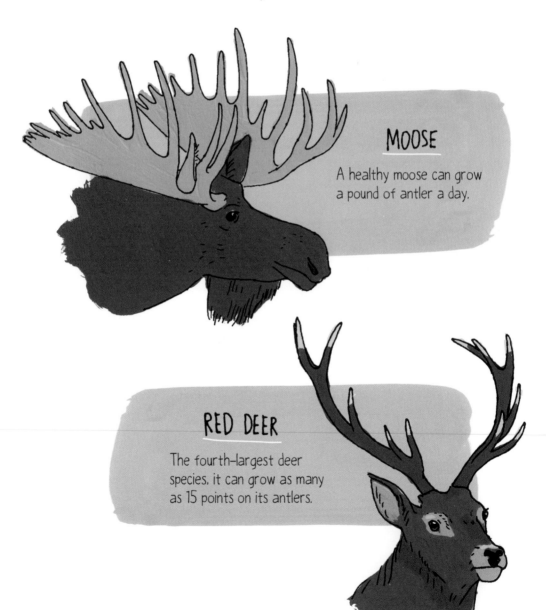

MOOSE

A healthy moose can grow a pound of antler a day.

RED DEER

The fourth-largest deer species, it can grow as many as 15 points on its antlers.

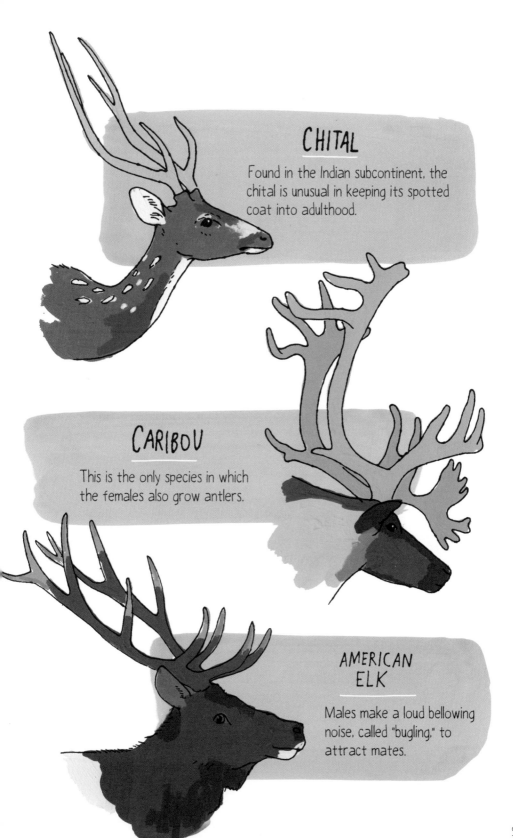

CHITAL

Found in the Indian subcontinent, the chital is unusual in keeping its spotted coat into adulthood.

CARIBOU

This is the only species in which the females also grow antlers.

AMERICAN ELK

Males make a loud bellowing noise, called "bugling," to attract mates.

THE ANTELOPE

The term "antelope" covers members of the Bovidae family that are not cows, sheep, or goats. There are 91 species of antelope, most of which are found in Africa.

Ranging in size from a mere 9 or 10 inches tall at the shoulder to nearly 6 feet, antelopes are ruminants, meaning they chew cud and have multichambered stomachs for digesting grass, leaves, and other vegetation. Males of all species have horns, not antlers; the females of some species have them as well.

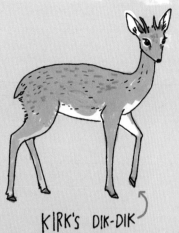

KIRK'S DIK-DIK

Tiny dik-diks mate for life. Their name reflects the sharp whistling alarm call of the female.

NYALA

Males have long, spiraling horns; the much smaller females do not. Both sexes have stripes but as males age, their stripes fade.

SITATUNGA

These medium-sized antelopes have curved, splayed hooves and shaggy, water-repellent coats suitable for living in marshy areas.

BONGO

A large antelope with a reddish coat striped with white, the bongo lives in dense forest. It nibbles burned wood to get salts and minerals from the charcoal.

ELAND

Males can weigh as much as a ton and stand 11 feet at the shoulder but are agile enough to jump a 4-foot fence from a standstill.

THE ROYAL ANTELOPE

The tiny royal antelope lives in dense rainforests in western Africa. Locally known as "the king of the hares," it weighs just 4 pounds. Like a hare, its hind legs are quite a bit longer than its front ones, enabling it to leap more than 9 feet in a single bound.

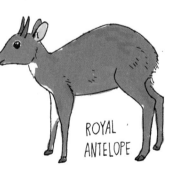

ROYAL ANTELOPE

HARE

ANATOMY OF A HOOF

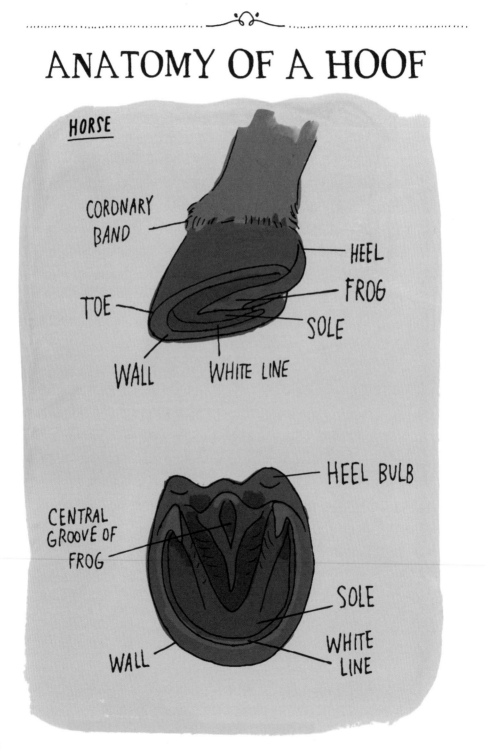

HORSE

CORONARY BAND

HEEL

FROG

TOE

SOLE

WALL

WHITE LINE

HEEL BULB

CENTRAL GROOVE OF FROG

SOLE

WALL

WHITE LINE

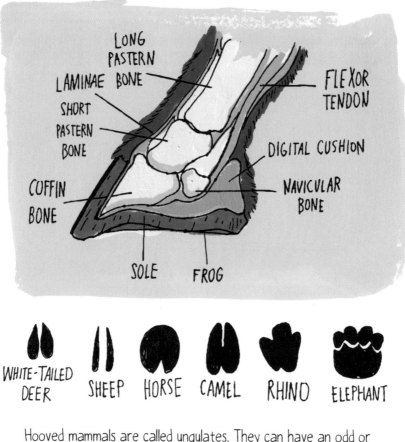

LONG PASTERN BONE

LAMINAE

SHORT PASTERN BONE

COFFIN BONE

FLEXOR TENDON

DIGITAL CUSHION

NAVICULAR BONE

SOLE

FROG

WHITE-TAILED DEER

SHEEP

HORSE

CAMEL

RHINO

ELEPHANT

Hooved mammals are called ungulates. They can have an odd or even number of toes, with a hard or rubbery sole. Hooves, like finger- and toenails, are made of keratin and grow continuously.

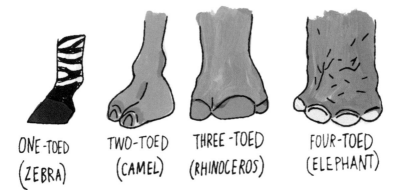

ONE-TOED (ZEBRA)

TWO-TOED (CAMEL)

THREE-TOED (RHINOCEROS)

FOUR-TOED (ELEPHANT)

ANATOMY OF A ZEBRA

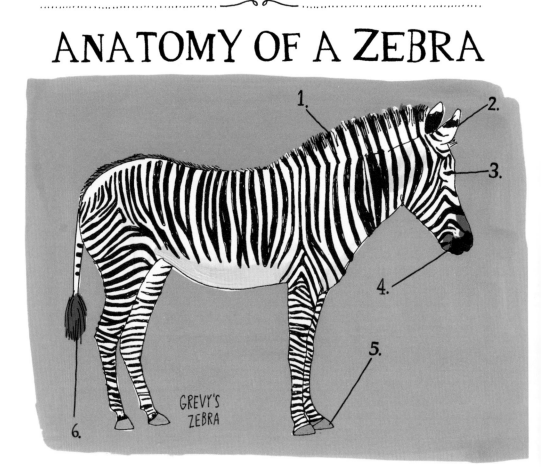

GREVY'S ZEBRA

1. **mane** stands upright with no forelock between the ears

2. **ears** large for excellent hearing

3. **eyes** widely spaced for seeing as well in the dark as an owl

4. **teeth** grow continuously and are worn down by grinding and chewing grass

5. **hooves** single-toed and strong for running up to 35 mph and kicking predators

6. **tail** tasseled for swatting away insects

Zebras are members of the Equidae family, making them cousins to the domestic horse. There are three main species of zebra: Grevy's, mountain, and plains. Each has a different pattern of stripes, and each individual animal has a unique pattern, like a fingerprint.

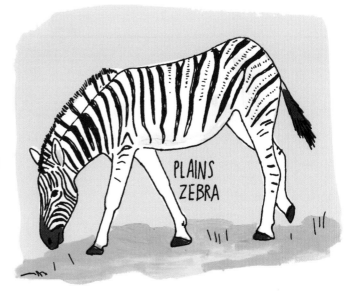

PLAINS ZEBRA

Zebras are usually described as having black stripes on a white background. Underneath the stripes, their skin is black. The stripes are thought to serve several purposes:

CAMOUFLAGE A herd of zebras blends together, making it hard for a predator to focus on a single animal.

INSECT REPELLENT Biting flies and other pests seem confused by striped surfaces and are less likely to land on them.

HEAT REGULATION Black hair absorbs heat, white hair reflects it.

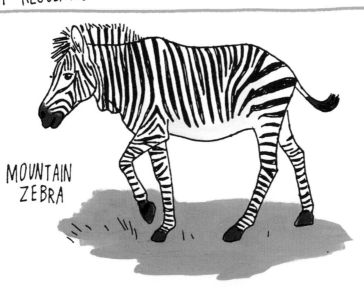

MOUNTAIN ZEBRA

WILD HORSES

The "wild horses" of the American West and many other locations are descended from domestic horses and are technically feral. The only truly wild horse is Przewalski's horse, native to the steppes of Mongolia.

The takhi, as it is called in Mongolia, was nearly wiped out in the early twentieth century, when just 14 remaining animals were captured from the wild. It is still very rare, with only about 2,000 alive. Most live in zoos, though a small herd was reintroduced to Mongolia in 1992.

PRZEWALSKI'S HORSE

WILD ASSES

SOMALI WILD ASS
the only wild ass with striped legs

ONAGER
three subspecies found in China, Mongolia, and parts of Asia

KIANG →
largest of the wild asses, standing 55 inches at the withers

The Curious Case of the Pronghorn Antelope

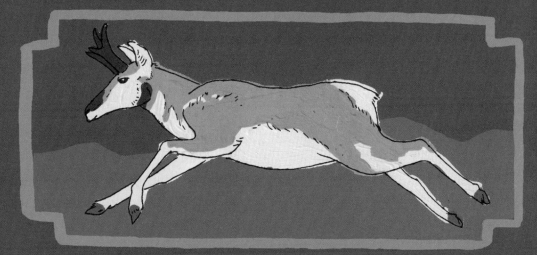

It's not an antelope, but related to the giraffe.

- Its horns are permanent but grow a layer of keratin that is shed annually, like antlers.

- Capable of hitting speeds of 55 mph, it is the second-fastest runner, after the cheetah, even though none of its natural predators can run anywhere near that fast.

- Depending on where they live, some pronghorns migrate seasonally (up to 150 miles), some migrate when conditions call for it, and others stay put year-round.

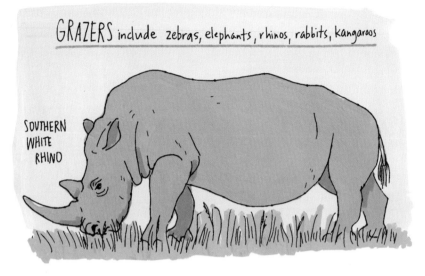

GRAZERS include zebras, elephants, rhinos, rabbits, kangaroos

SOUTHERN WHITE RHINO

Herbivores can be divided into two categories based on their diets. Browsers eat leaves, tree bark and twigs, shrubs and bushes, and higher-growing plants. Grazers eat mainly grasses and other low-growing plants.

GRAZING vs. BROWSING

Grazers and browsers often coexist in a habitat because they don't compete for food. Many of them have specialized gut bacteria to help digest the large amounts of cellulose and fiber they consume.

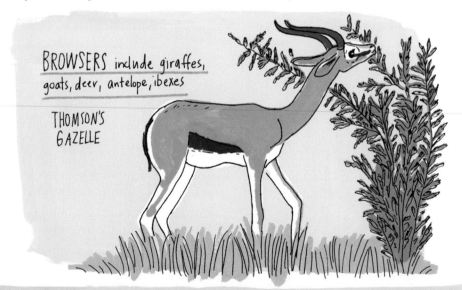

BROWSERS include giraffes, goats, deer, antelope, ibexes

THOMSON'S GAZELLE

Musk Oxen

Superbly adapted to the Arctic terrain where they live, musk oxen have a thick double coat, with long heavy guard hairs over a layer of fine short wool called qiviut. The undercoat is shed in the spring and used by Inuit knitters to make scarves, hats, and other garments.

Musk oxen have no natural predators other than wolves and the occasional bear. When under attack, the herd gathers in a circle with calves and vulnerable individuals in the middle. Standing shoulder to shoulder, with sharp horns facing out, it is a pretty effective strategy.

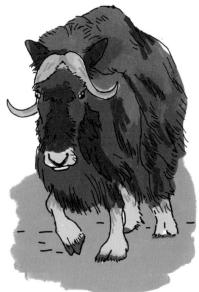

The name comes from the distinctive odor given off by the males during the breeding season.

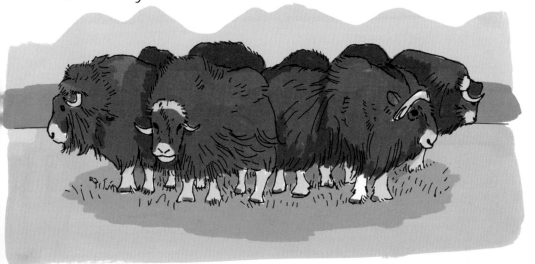

Bison

Though the terms "bison" and "buffalo" are sometimes used interchangeably, these are different species that are not closely related. The American bison and its European cousin are massive animals that live on grassy plains and in forests.

With thick shaggy coats and stocky bodies, they are well adapted to harsh winters. They use their large neck humps and heavy skulls to push aside snowdrifts to find grass. Both males and females have short curved horns.

Tens of millions of bison used to roam the plains and forests of North America and Europe, but their numbers were drastically reduced in the nineteenth and twentieth centuries.

An estimated 30,000 American bison live in managed herds in national parks, with many thousands more being raised in captivity for meat. The European bison was hunted to extinction in the wild but has been reintroduced in a few countries.

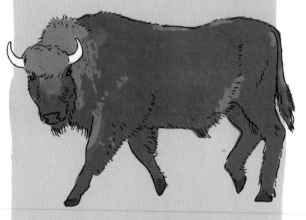

AMERICAN BISON

EUROPEAN BISON

Bison are surprisingly agile for their bulk. They can run 35mph and jump 4-foot fences.

Cape Buffalo

The Cape buffalo displays some unusual behaviors compared to other bovines. Calves, for example, nurse from behind their mothers rather than next to them.

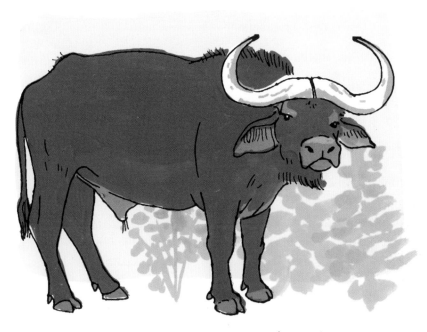

Bulls have sweeping horns that can measure 6 feet from tip to tip.

Cows communicate visually by facing a desired direction of travel. When enough of them are facing the same direction, off they go. Cape buffalo are known to go after people and lions that have attacked them in the past.

A BIT ABOUT ELEPHANTS

The trunk is a combination nose and upper lip that is strong enough to uproot a tree and sensitive enough to pluck a blade of grass. Elephants use their trunks like humans use their hands, but they also breathe through them and drink with them, by sucking water up partway then releasing it into their mouths.

Elephants eat all kinds of vegetation depending on the season, including grasses, shrubbery, leaves, fruit, and the twigs and bark of small trees. It takes an average of 16 hours a day to find and consume the amount of food needed for such an active metabolism.

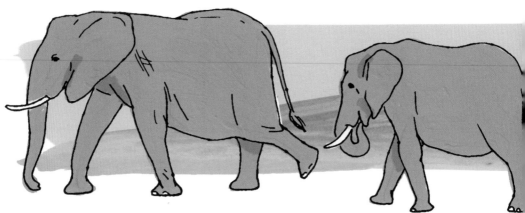

Even though it can be an inch thick in places, elephant skin is remarkably sensitive to insects and sunburn. Elephants protect their skin by bathing in water, rolling in mud, or throwing dirt on themselves. The deep wrinkles trap moisture to help cool the animal off. Flapping their ears is another way elephants keep from overheating.

ELEPHANT SOCIETY

A herd of elephants is led by a matriarch, usually the oldest female, whose long memory and life experience guide the group to food, water, and safety. Females typically stay with the herd while adolescent males form bachelor herds. Older males are frequently solitary for long stretches of time. Family groups travel widely to find food and come together in larger groups.

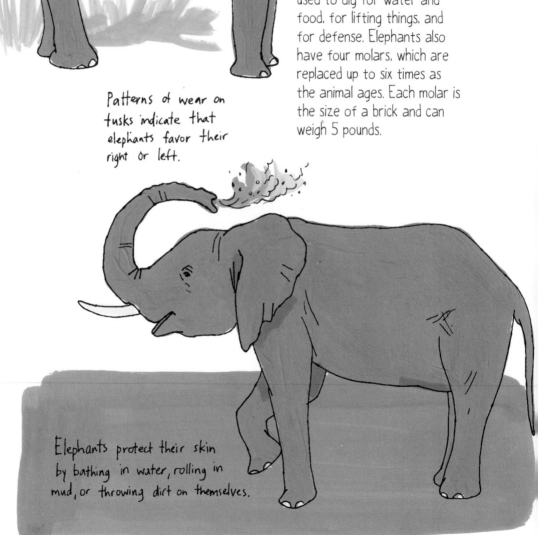

Tusks grow throughout the elephant's lifetime. They are used to dig for water and food, for lifting things, and for defense. Elephants also have four molars, which are replaced up to six times as the animal ages. Each molar is the size of a brick and can weigh 5 pounds.

Patterns of wear on tusks indicate that elephants favor their right or left.

Elephants protect their skin by bathing in water, rolling in mud, or throwing dirt on themselves.

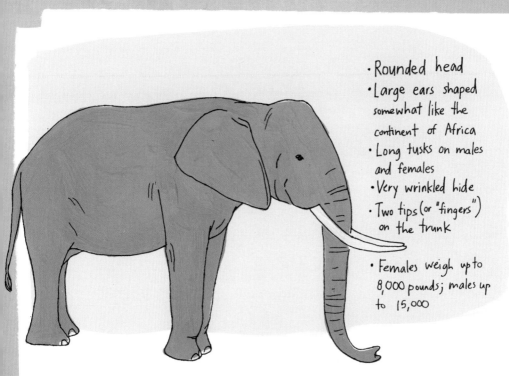

- Rounded head
- Large ears shaped somewhat like the continent of Africa
- Long tusks on males and females
- Very wrinkled hide
- Two tips (or "fingers") on the trunk

- Females weigh up to 8,000 pounds; males up to 15,000

AFRICAN ELEPHANT
VS.
ASIAN ELEPHANT

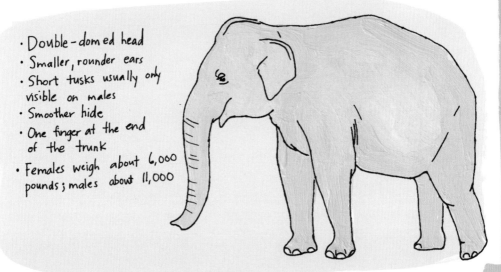

- Double-domed head
- Smaller, rounder ears
- Short tusks usually only visible on males
- Smoother hide
- One finger at the end of the trunk
- Females weigh about 6,000 pounds; males about 11,000

Elephants probably have the most famous noses of all animals. They not only breathe through their long, sensitive trunks, they use them for eating and drinking, bathing and cooling off, and picking up and moving branches and other items.

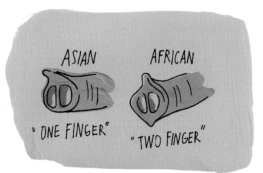

ASIAN
"ONE FINGER"

AFRICAN
"TWO FINGER"

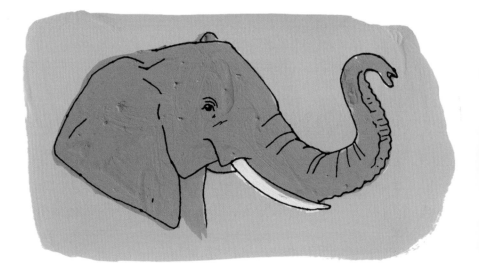

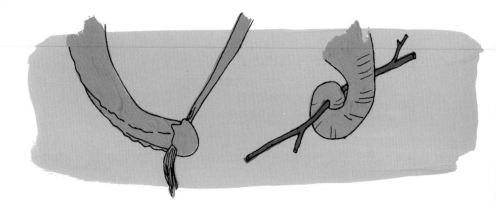

ELEPHANT NAMESAKES

ELEPHANT SHREW

Elephant shrews, surprisingly, are actually related to elephants back through millennia to a common ancestor that puts them in a group called Afrotheria (mammals that evolved from a common African ancestor).

ELEPHANT SEAL

Elephant seals use their impressive snouts to recapture moisture from their breath, which helps them stay hydrated while on land. Males, who have much larger trunks, also inflate them to make roaring noises during breeding season.

ELEPHANT NOSE FISH

Elephant nose fish have elongated chins that emit a weak electric pulse that helps them find food.

HIP, HIP, HIPPO-RAY

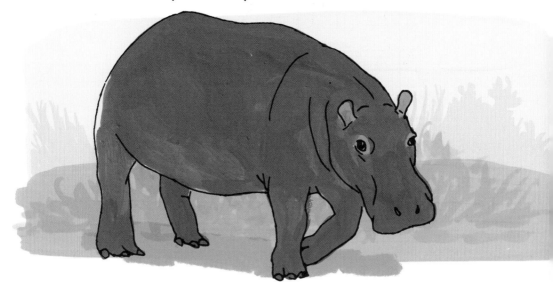

A bull hippopotamus can weigh as much as 5,000 pounds. Hippos live in herds, spending the day mostly in the water and emerging at night to graze. Surprisingly nimble on land, they are very dangerous in the water and have a well-earned reputation for attacking boats.

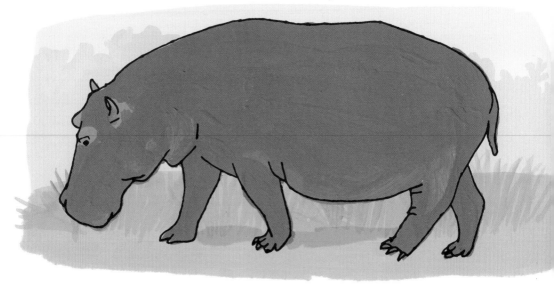

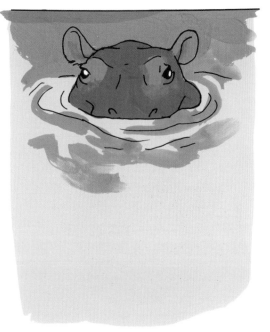

The hippopotamus is one of the largest land animals, along with elephants and rhinos.

Hippos can open their enormous jaws 150 degrees. Males use their large, sharp canine teeth to drive off rivals, often leading to serious wounds.

Instead of sweating, hippos produce an oily red liquid that keeps their skin from drying out, protects against sunburn, and appears to help prevent infection.

While defecating, hippos use their thick, flat tails to spread their excrement to mark territory and establish dominance.

The Hoatzin

Unique among birds, the hoatzin (pronounced "watson") eats leaves almost exclusively. It uses bacteria in its gut to digest its food, much like deer and cows. The hoatzin's two-chambered crop is so large that these birds don't have much muscle mass and are clumsy flyers.

Because of their digestive process, hoatzins have an unpleasant odor and are not much hunted by humans.

Hoatzins live in the Amazon in gregarious colonies in seasonally flooded forests. They build stick nests in trees overhanging water.

When threatened by predators, such as snakes or monkeys, the chicks jump into the water. They can swim and are born with hooked claws on their wings, which they use to clamber back up to their nests.

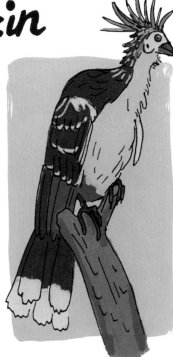

Hoatzins are nicknamed "the stinkbird."

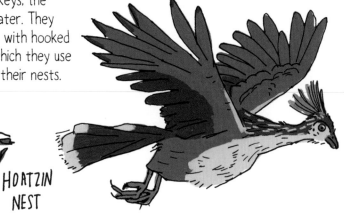

HOATZIN NEST

OXPECKERS AND CATTLE EGRETS

Ticks, flies, and other parasites are a serious problem for many herd animals. These two very different birds act as a clean-up crew for a wide range of species besides oxen and cattle.

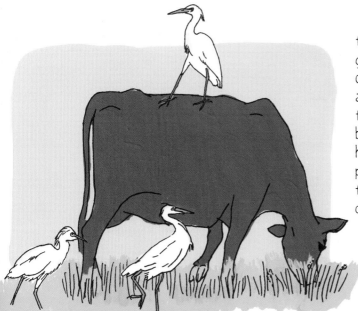

CATTLE EGRETS

follow herds of grazing animals to catch grasshoppers and small vertebrates that are stirred up by the passing hooves. They also pick ticks and biting flies from the hides of the larger animals.

YELLOW-BILLED OXPECKERS

have flat beaks for combing through hair and extralong claws for clinging at any angle. A single bird can eat hundreds of ticks a day, benefiting animals as diverse as warthogs, giraffes, lions, and hippos. They also snack on earwax and have a taste for blood, which leads them to peck at open wounds to keep the blood flowing.

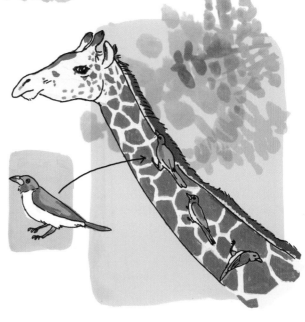

Llama
+
Alpaca

Llamas and alpacas are domesticated pack animals native to South America. Prized for their wool, they are found all over the world.

A baby llama or alpaca is called a cria.

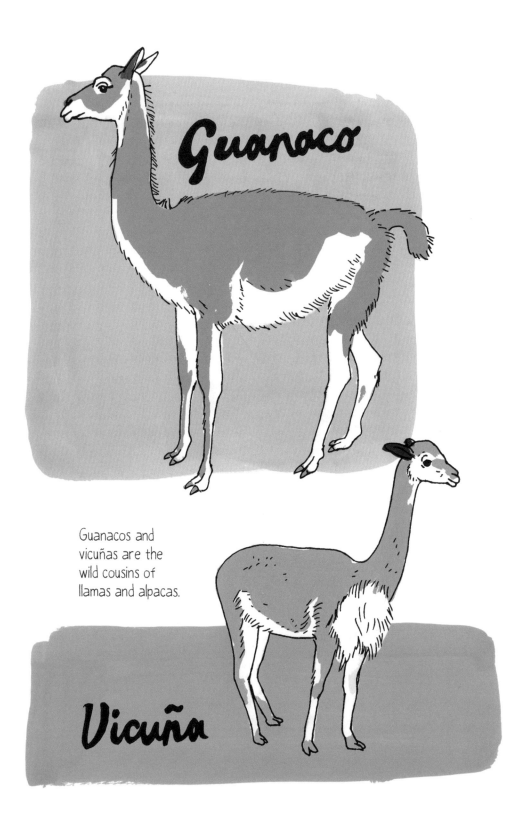

Guanaco

Guanacos and vicuñas are the wild cousins of llamas and alpacas.

Vicuña

ANATOMY OF A CAMEL

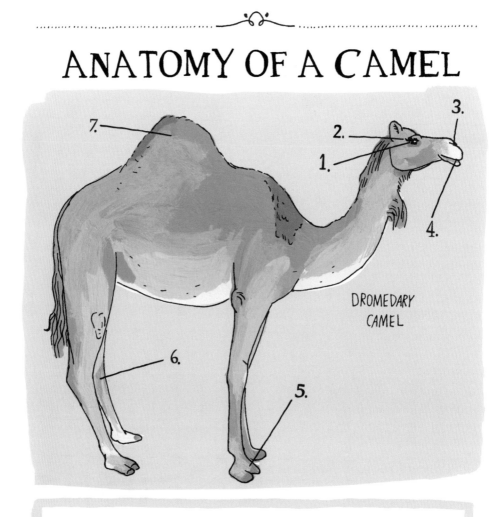

DROMEDARY CAMEL

1. nictitating eyelid an inner membrane that slides over the eye to protect it

2. eyelashes very long and in a double row to keep out dust

3. nostrils can close during sandstorms

4. lips split upper lips move independently

5. feet two toes in a thick, leathery pad that expands for moving on sand

6. hind legs fold like hinges when the animal lies down

7. hump stores fat, not water

Camels eat a variety of plant matter, including cactus—spines and all. With sufficient fat stored in its hump, a camel can survive for more than a week without water and several months without food.

Unlike most mammals, Bactrian camels can drink brackish water. A thirsty camel might drink 30 gallons of water in just a few minutes.

BACTRIAN
CAMEL

Like giraffes, camels move by pacing; that is, the front and rear leg on the same side of the body move together, rather than the front and opposite rear leg moving together. This efficient gait enables them to reach sustained speeds of up to 25 mph.

CHAPTER 4

Social Networks

PRIMATE POPULATIONS

The order of primates includes a range of very diverse species, from tiny marmosets and large-eyed lorises to mandrills—the largest of all the monkeys—and the massive mountain gorilla. Primates are found in many parts of the world, though most species live in particular areas.

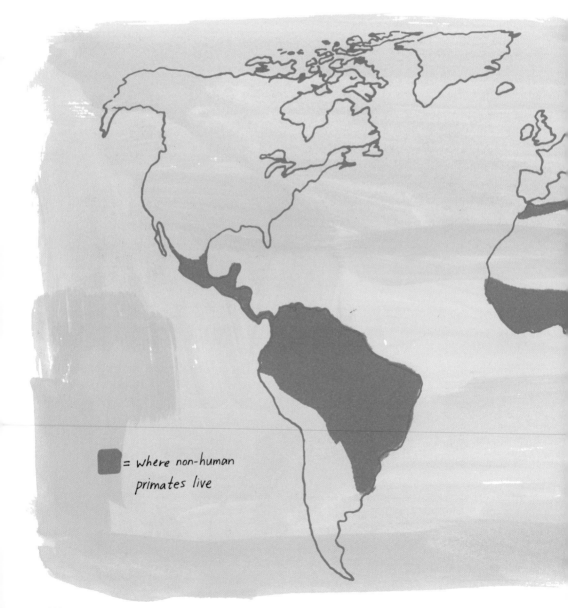

= where non-human primates live

Humans are the only primate species that is widespread around the globe.

About 60 percent of primates are endangered or threatened with extinction, primarily due to habitat loss.

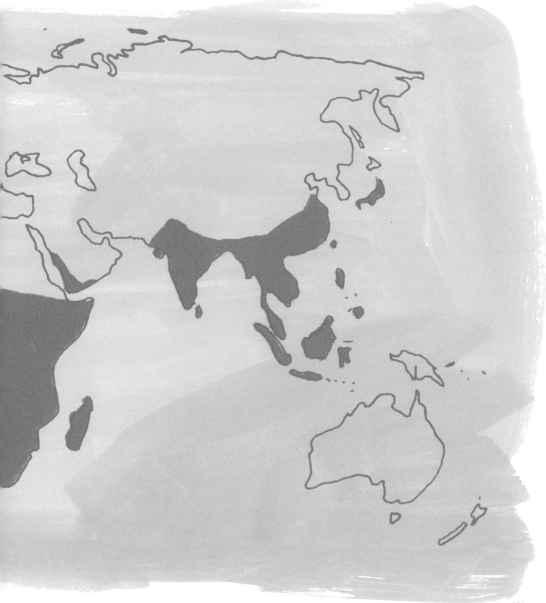

APES

GIBBONS are the smallest of the apes. Unlike their much larger cousins, they are primarily arboreal, with long, slender arms and hooked fingers for swinging through tree branches with great agility, a form of locomotion called "brachiating."

LAR GIBBON

Most gibbons are born white, gradually changing color as they age. In some species, males have black fur, while females are buff or tan.

When gibbons walk on their hind legs, they often carry their long arms over their heads.

CHIMPANZEES share more than DNA with humans. Like us, they live in complex, hierarchical social groups, form emotional bonds with family and friends, and communicate in a variety of ways. Chimps are highly territorial and will fight and even kill interlopers from other groups.

In addition to modifying twigs to fish for termites and bashing nuts open with rocks, troops work together to hunt other animals such as monkeys and small antelope.

Chimpanzees are more closely related to humans than they are to gorillas.

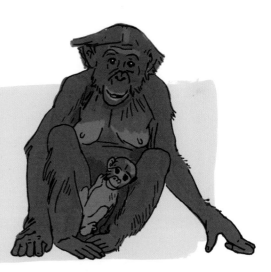

BONOBOS are smaller and slimmer than chimpanzees. They live only in the Democratic Republic of Congo in Central Africa. Their cooperative, conflict-averse, and matrilineal society is quite unusual among primates.

ORANGUTANS live only Borneo and Sumatra, where slash-and-burn deforestation to create palm oil plantations has forced them to the brink of extinction. These mostly solitary, tree-dwelling apes eat mainly fruit. Males are approximately twice the size of females and as they mature, some develop large, fleshy cheek pads called "flanges." Females give birth only every 8 years or so, and care for each infant for several years.

GORILLAS are divided
into two species, eastern
and western, and several
subspecies; all are critically
endangered. Gorillas live in
densely forested parts of
sub-Saharan Africa. These
gentle vegetarians live in
small family groups led by
a mature male, known as a
"silverback" for the much
lighter hair that begins to
appear when males are
about 10 years old.

CATARRHINES

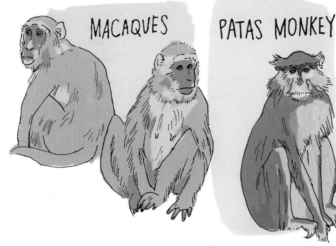

MACAQUES

PATAS MONKEY

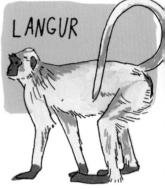

LANGUR

- Live in Africa, Asia, and Gibraltar
- Can be either terrestrial or arboreal
- Tails are not prehensile; some species have no tail
- Protruding muzzle with nostrils close together
- Live in mixed-sex troops; males rarely participate in rearing young

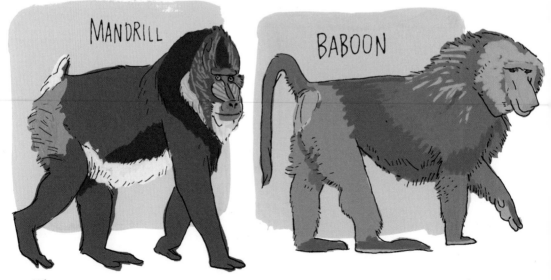

MANDRILL

BABOON

PLATYRRHINES

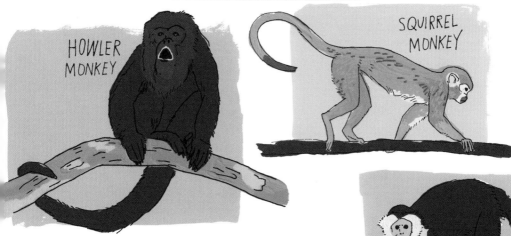

HOWLER MONKEY

SQUIRREL MONKEY

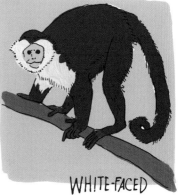

WHITE-FACED CAPUCHIN

- Live in Central and South America
- Most species are primarily arboreal
- Have long tails; prehensile in some species
- Flat noses with widely spaced nostrils
- Live in family groups; monogamous pairs raise young

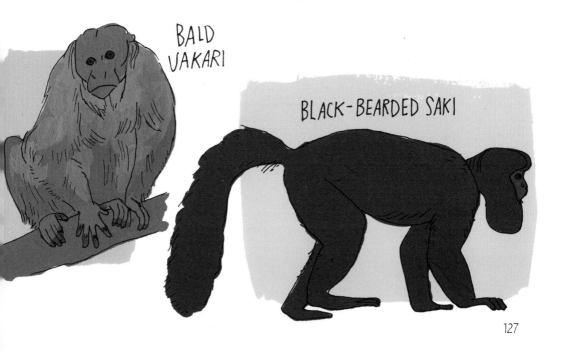

BALD UAKARI

BLACK-BEARDED SAKI

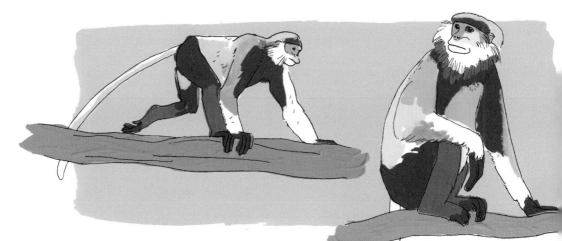

The Red-shanked Douc Langur

This gorgeously attired monkey is sometimes called the "queen of the forest" or the "costumed ape." Both sexes sport fluffy, multi-colored fur: a silvery back and belly set off with black shoulders and thighs, white forearms, and the bright chestnut "leggings" that give the species its name.

A matching chestnut throat patch, a black cap, and a fringe of white frame the two-toned peach-colored face with its dainty nostrils and powder-blue eyelids. The long white tail is framed with a triangular patch. Males have white spots above the triangle.

MARMOSETS AND TAMARINS

EMPEROR
TAMARIN

These small primates eat fruit, flowers, and insects, and use their teeth to scrape sap and resin from tree bark.

They typically live in small family groups of related individuals. Usually only one female in the group produces young at a time, and the whole group helps care for them. The babies are almost always twins.

PYGMY
MARMOSET

COMMON
MARMOSET

Marmosets and tamarins have claws rather than nails and lack an opposable thumb.

GOLDEN LION
TAMARIN

129

SOCIAL GROOMING

Grooming between individuals can play an important role in communicating, forming bonds, maintaining social order, and removing parasites.

Macaws reinforce pair bonds by preening their mate's feathers.

Honey bees clean pollen and dust from each other.

Zebras and other equines nibble along their grooming partner's neck and shoulders.

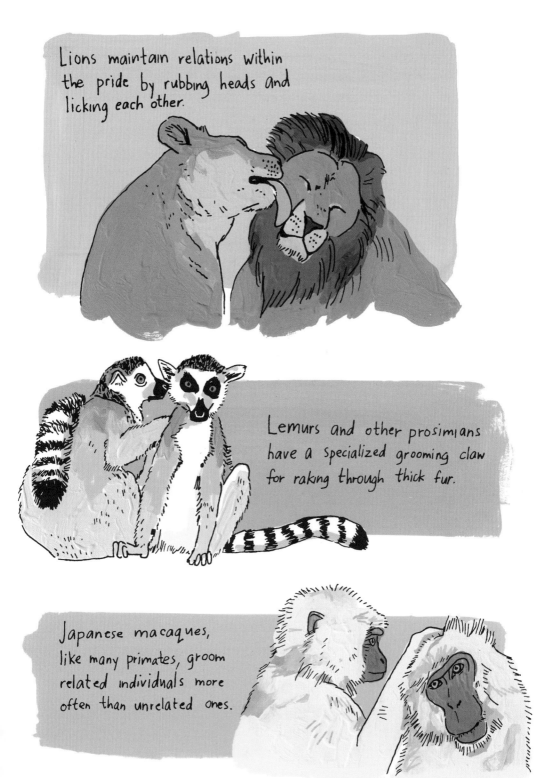

Lions maintain relations within the pride by rubbing heads and licking each other.

Lemurs and other prosimians have a specialized grooming claw for raking through thick fur.

Japanese macaques, like many primates, groom related individuals more often than unrelated ones.

131

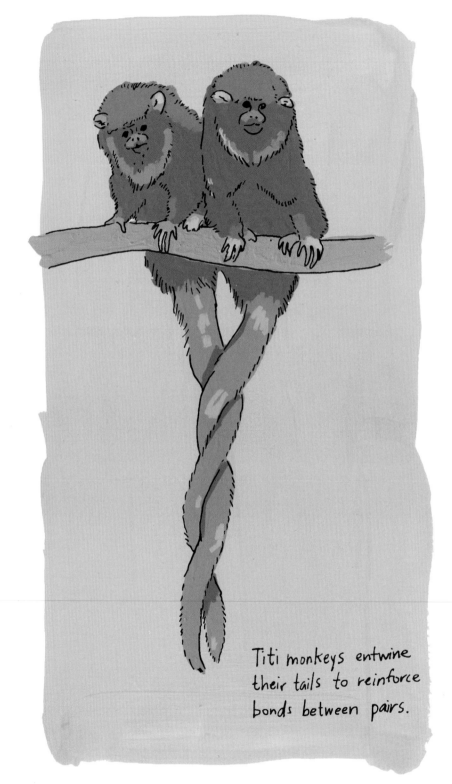

Titi monkeys entwine their tails to reinforce bonds between pairs.

A FEW PINNIPEDS

Most pinnipeds (seals, sea lions and fur seals, and walruses) come together in large groups during breeding season.

STELLER'S SEA LIONS

communicate both on land and underwater by snorting, hissing, belching, and growling, and making clicking sounds.

CALIFORNIA SEA LIONS

gather in huge colonies or rookeries along the west coast of North and Central America.

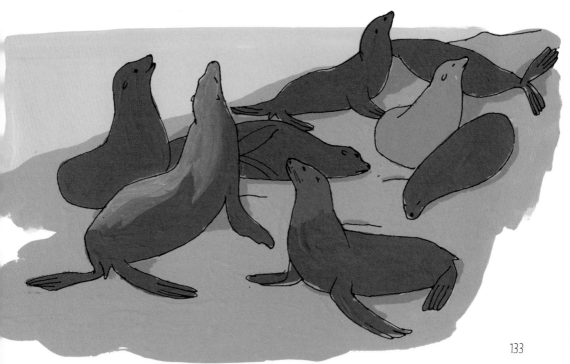

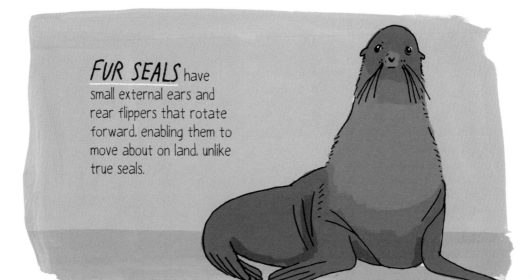

FUR SEALS have small external ears and rear flippers that rotate forward, enabling them to move about on land, unlike true seals.

WALRUSES are among the largest of the pinnipeds, with males weighing as much as 3,000 pounds and measuring 10 feet long. Females are about half as big as males. Both sexes have tusks, which are external canine teeth that can grow to 3 feet, and a thick mustache of whiskers.

They use their tusks to break breathing holes in ice and assist in hauling out of the water. Males use them to vigorously defend territory and fight for breeding privileges. Walruses use their sensitive whiskers to forage on the sea floor for shrimp, crabs, mollusks, and a variety of other marine life.

ELEPHANT SEALS

can grow to 7,000 pounds, making them many times larger and heavier than polar bears.

WEDDELL SEALS

hunt beneath the ice in Antarctica, blowing bubbles into the ice ceiling to scare out fish hiding in the crannies.

Banded Mongoose

- Found in savannas and open forest in east, southeast, and south-central Africa, they eat mostly insects.
- They form mixed-sex packs of up to 40 individuals, but more commonly about 20.
- As a defense against predators, the group will bunch up and move together to look like one large animal.
- Young mongooses shadow an unrelated adult to learn how to forage.

Meerkat

- Found in southern Africa on dry, open grasslands, they eat mostly insects.
- They live in "mobs" of 10 to 15 animals, made up of different family groups.
- Highly social, they communicate with at least 10 different vocalizations, including murmurs, growls, and a defensive alarm bark.

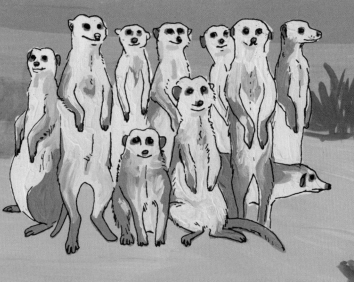

Sentinels take turns to watch out while the mob feeds and plays.

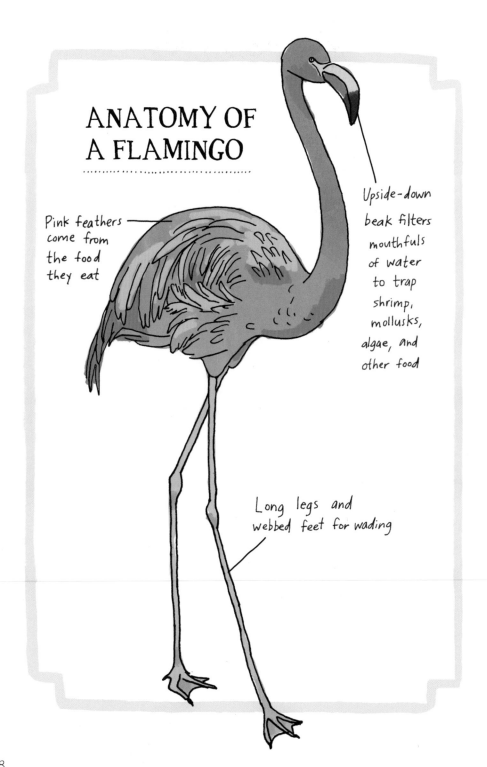

ANATOMY OF A FLAMINGO

Pink feathers come from the food they eat

Upside-down beak filters mouthfuls of water to trap shrimp, mollusks, algae, and other food

Long legs and webbed feet for wading

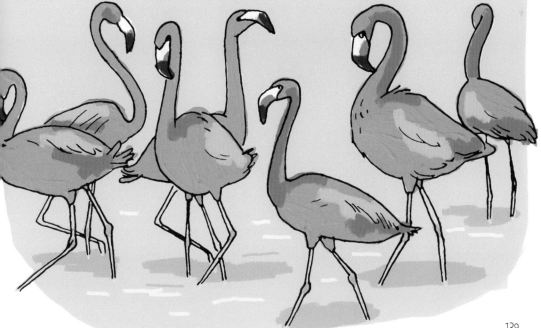

A Flamboyance of Flamingos

Most of the world's six species of flamingos live in
South America and Africa, where they congregate in
huge colonies. The chicks are born white, with straight
beaks that curve as they grow.

Naked Mole Rat

Ants and bees are well-known examples of "eusociality," in which the group is more important than the individual. In such a society, the colony revolves around a breeding queen who produces all the offspring. Other members have specialized roles such as tending to larvae, gathering food, or defending against threats.

The naked mole rat is one of only two known mammals with a similarly advanced social structure (the other is the Damaraland mole rat).

QUEEN

An average litter is 12, but there can be up to 30 pups, the most of any mammal.

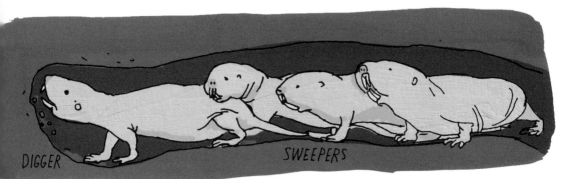

DIGGER

SWEEPERS

Diggers work in teams, passing dirt back up
to the surface in an assembly line fashion.

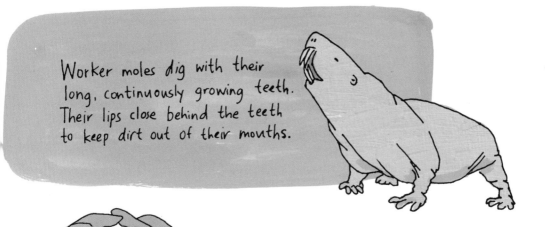

Worker moles dig with their
long, continuously growing teeth.
Their lips close behind the teeth
to keep dirt out of their mouths.

They eat tubers and other underground
parts of plants. They do not drink at all.

For such tiny animals,
they have an incredibly
long lifespan, living up to
30 years in captivity.

GO TO BAT

Bats are the second-largest order of mammals, after rodents, with some 1,400 species found worldwide. They play a vital role in their ecosystems by consuming insect pests, pollinating plants, and dispersing seeds.

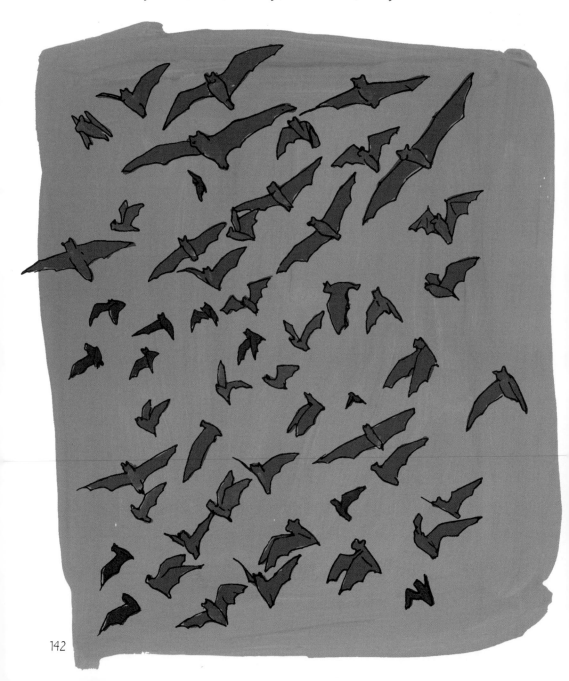

wingspan up to 6 feet

GIANT GOLDEN-CROWNED FLYING FOXES

and other large flying foxes are the largest species of fruit bats. Found in Malaysia and the Philippines, they live together in colonies of several hundred to several thousand animals.

wingspan 6 ½ inches

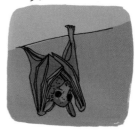

BUMBLEBEE BAT →

The smallest mammal in the world has no tail but surprisingly large ears. Even its colonies are tiny, with the largest numbering fewer than 100 bats. It lives in western Thailand and Myanmar.

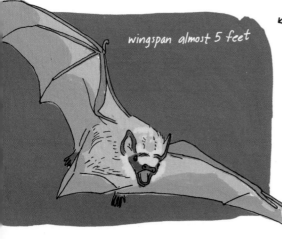

wingspan almost 5 feet

⟵ HOARY BAT

This is one of the few solitary bat species. Widespread across North America, it migrates to warmer climates in the winter. During the day, it hangs from a branch by one foot and imitates a dried leaf by wrapping its tail membrane around itself.

GOING TO THE DOGS

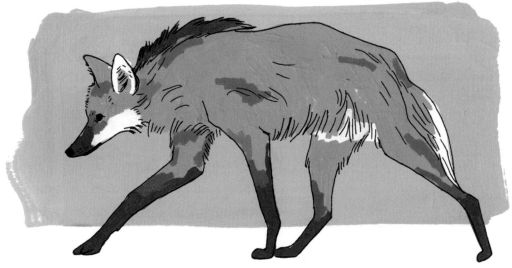

Maned Wolf

The largest canine in South America is the only member in its genus, *Chrysocyon*. Its urine smells like skunk spray.

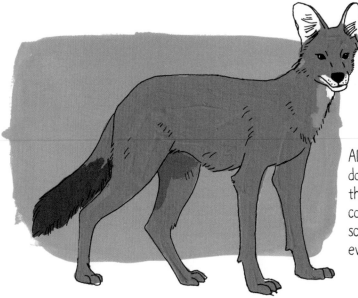

Dhole

Also called the Asian wild dog or whistling dog, these largish canines communicate by whistling, screaming, mewing, and even clucking.

Ethiopian Wolf

This specialized hunter of rodents is the rarest canine in the world, with fewer than 500 individuals remaining.

African Wild Dogs

These highly social canines hunt in a group and raise young cooperatively. They communicate through a variety of body postures and vocalizations, including sneezing. Unusual among social species, males remain with their natal pack and females disperse to find a new one.

FEELING FOXY

FENNEC FOX

The smallest member of the fox family has ears that can measure a third of its overall length.

ARCTIC FOX

Its thick coat, heavily furred feet, and small ears are adaptations for surviving temperatures well below zero.

BENGAL OR INDIAN FOX

Found only on the Indian subcontinent, these slender foxes feed on a variety of insects, small rodents and birds, and plant matter.

BLANFORD'S FOX

Well-suited for climbing and jumping over rocky terrain, it has curved claws for clinging and a wide, thick tail for balance.

SWIFT FOX

About the size of a cat, this once nearly extinct fox is making a comeback in the Great Plains region and southeastern Canada.

CHAPTER 5

Built from the Ground Up

THE LANDLORDS

The pileated woodpecker is a keystone species. Monogamous pairs excavate large holes in dead trees and rarely reuse a nest, thereby creating housing for at least 20 other species, including big brown bats, ringtail cats, and northern flying squirrels.

Many different animals use burrows for shelter.

Primary Excavators: actually dig the burrows

Secondary Modifiers: animals that take over an abandoned burrow and change or improve parts of the burrow to suit them

Occupants: just use the burrows as is

The gopher tortoise is a good example of a primary excavator. Weighing only 15 pounds but equipped with powerful legs and strong claws, this keystone species digs out tunnels up to 40 feet long and 10 feet deep. Hundreds of other species, including owls, coyotes, frogs, and mice, use these burrows for shelter and to seek protection from predators, heat, and fires.

A GOPHER TORTOISE DEN

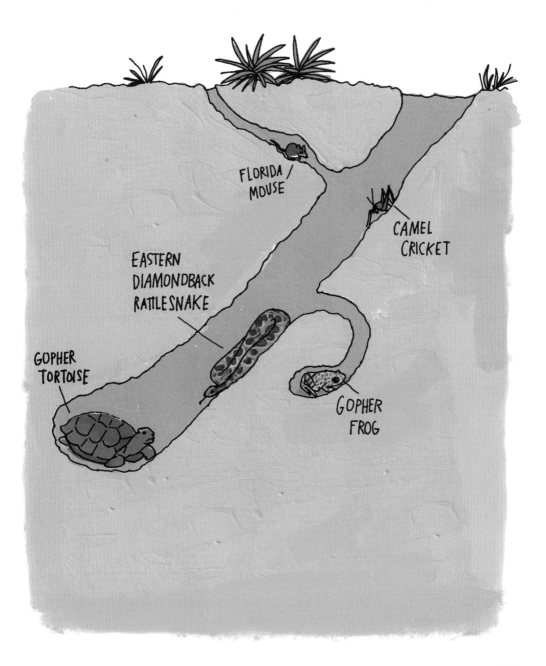

FLORIDA / MOUSE

CAMEL CRICKET

EASTERN DIAMONDBACK RATTLESNAKE

GOPHER TORTOISE

GOPHER FROG

European Badger

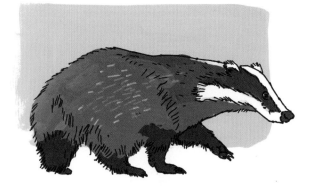

More social than their American cousins, European badgers live in extended, multichambered burrows called setts. Several families might occupy a large sett, which can have several nesting and sleeping dens per family, all connected by tunnels.

An established sett, dug out and maintained by generations of badgers, has a number of exits and may cover an area of several hundred square yards.

A male badger is a boar and a female is a sow, but the babies are called cubs.

AIR VENTS

TOILET

BEDROOM

LISTENING ROOM

DRY ROOM

BEDROOM
(About 12 inches diameter)

NURSERY

SECRET EMERGENCY EXIT

BEDROOM

FOOD CACHE

Abandoned dens and nesting cavities of all shapes and sizes provide living spaces for countless species of animals. Prairie dog towns, for example, may be shared by snakes, burrowing owls, and even rare black-footed ferrets, which also prey on their landlords.

Aardvark dens are used by hyenas, warthogs, squirrels, hedgehogs, mongooses, bats, birds, and reptiles.

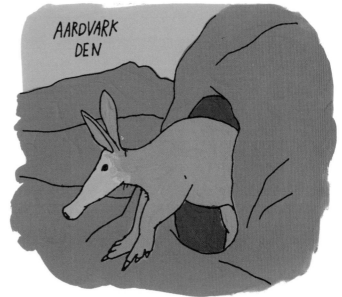

AARDVARK DEN

INSECT ARCHITECTURE

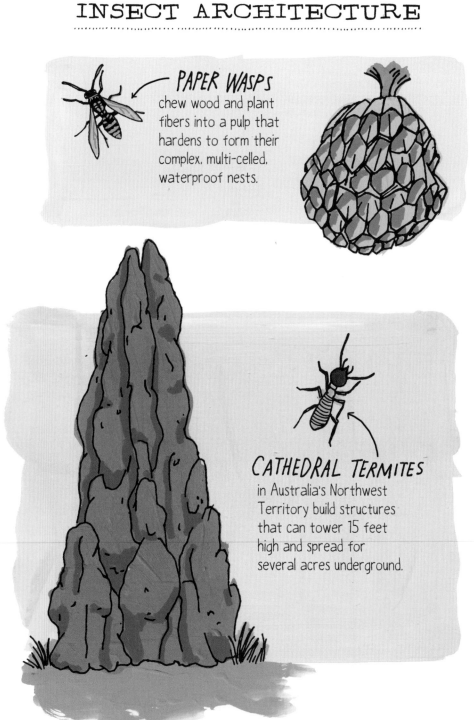

PAPER WASPS chew wood and plant fibers into a pulp that hardens to form their complex, multi-celled, waterproof nests.

CATHEDRAL TERMITES in Australia's Northwest Territory build structures that can tower 15 feet high and spread for several acres underground.

WEAVER ANTS form living bridges to move to a new nesting site. Worker ants carry larvae across the bridge, then squeeze them to produce silk to join the edges of leaves together to form a pouch. A large weaver ant colony can cover the entire canopy of a tree.

EASTERN TENT CATERPILLARS hatch in the early spring. To protect themselves against chilly temperatures, up to 300 caterpillars weave large 3D webs using several branches as anchor points.

CADDISFLY LARVA encase themselves in a protective tube made of plant matter, snail shells, and other material, held together with silk threads. They carry this "house" around with them until they pupate.

SPIDER WEBS

SHEET-WEAVING SPIDER

Tiny sheet-weaving spiders entangle their prey in a closely woven net of non-sticky silk, usually constructed close to or on the ground.

FUNNEL-WEB SPIDER

Funnel-web spiders build a two-part web: a flat surface for trapping prey and an attached funnel-shaped burrow for hiding, eating, and laying eggs.

GOLDEN-SILK ORB WEAVER

The golden-silk orb weaver spins large webs of yellow silk. The color seems to shine brightly in sunlight, attracting bees, and blend into shady backgrounds where other insects are likely to be trapped.

Female golden-silk orb weavers can be 2 inches long, not including their distinctively tufted legs.

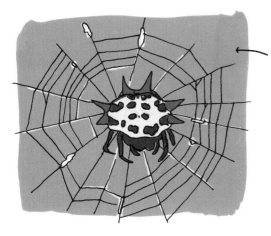

SPINY-BACKED ORB WEAVER

The small but distinctive spiny-backed orb weaver decorates its web with tufts of silk, possibly as a visual warning to birds to avoid flying into it.

TRAP-DOOR SPIDER

Trap-door spiders dig tunnels with their specialized mouthparts. They seal the entrance with a hinged door, made of silk, that is often camouflaged from the outside. Timid by nature, they hide in their tunnels waiting to pounce on passing prey, which they detect by vibration.

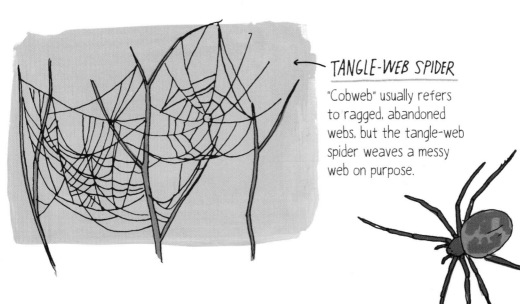

TANGLE-WEB SPIDER

"Cobweb" usually refers to ragged, abandoned webs, but the tangle-web spider weaves a messy web on purpose.

FEATHER YOUR NEST

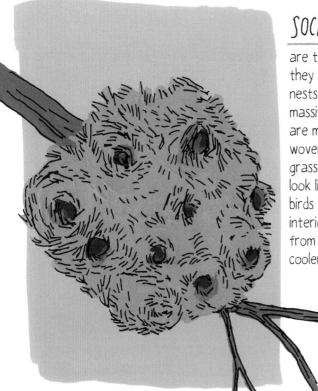

SOCIABLE WEAVER BIRDS

are the size of sparrows but they build the largest communal nests in the avian kingdom. These massive, permanent structures are made of individual chambers woven from twigs, straw, and grasses. From the outside they look like a giant haystack. The birds huddle for warmth in interior chambers and seek relief from the heat and sun in the cooler outer chambers.

A single nest may house up to 100 breeding pairs and include several generations. The young from one hatching help raise the next batch of siblings, which increases the likelihood of survival.

Sociable weavers live in the southern Kalahari region of Africa.

CLIFF SWALLOWS nest in large breeding colonies built of individual mud nests attached to cliffs, bridges, or highway overpasses. Mated pairs may repair their old nest for use the following year or may choose to build a new one.

HAMERKOPS build the largest domed nests of any bird. A nest, which may weigh 55 pounds, can take two months to build, requires approximately 10,000 sticks, and is lined with mud. It has a single entrance hole, which the birds fly directly into when entering.

LONG-TAILED TITS

build their nests with over
6,000 individual pieces of moss,
spider egg cocoons, lichen, and
feathers. Both parents weave the
moss and cocoons into a flexible
mesh sack with a small opening on
top. They cover the outside with
lichen for camouflage and line the
cavity with feathers for insulation.

GILA WOODPECKERS

usually dig out
their cavity nests
in saguaro cacti.

MALLEEFOWL

MALLEEFOWL males dig a crater in the sand and fill it with organic matter. Over several months, they tend and turn the material as it composts and creates heat. Their mates eventually lay anywhere from 3 to 30 eggs in the mound and cover them with sand.

The parents regulate the temperature of the nest by removing and replacing sand. After hatching, the young birds must dig their way to the surface.

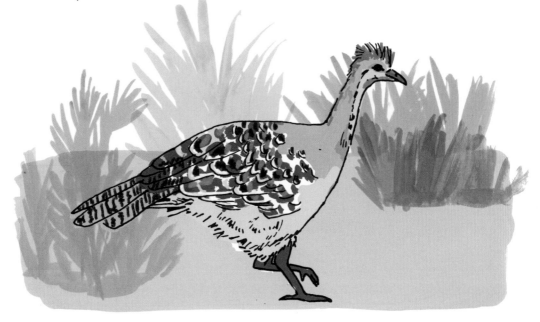

BURROWING BIRDS

BANK SWALLOWS nest in large colonies in cliffs or vertical riverbanks with sandy soil. Males use their beaks, feet, and wings to dig out an approximately 2-foot-long tunnel with a nesting chamber. Females line the chamber with a flat nest mat made of grasses, leaves, and rootlets.

ATLANTIC PUFFINS

spend most of the year at sea but congregate on islands during breeding season. Pairs mate for life and typically return every year to their nest, which they dig with their bills and feet. Both parents fly many miles a day to bring fish to their single puffling, as the young are called.

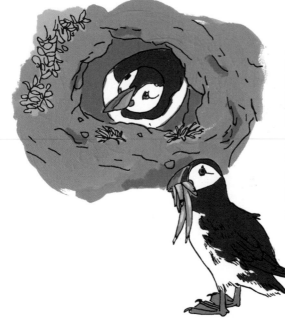

BELTED KINGFISHER

pairs excavate tunnels in riverbanks. The burrow, which slopes upward so rain won't collect in the nesting chamber at the end, may be 6 feet long.

Bowerbirds

Male bowerbirds build and decorate elaborate structures to attract mates. Different species use different materials and exhibit distinct color preferences. Some even paint their structures with berry juice! After choosing a male to mate with, the female builds a nest on her own and raises the babies without the male's help.

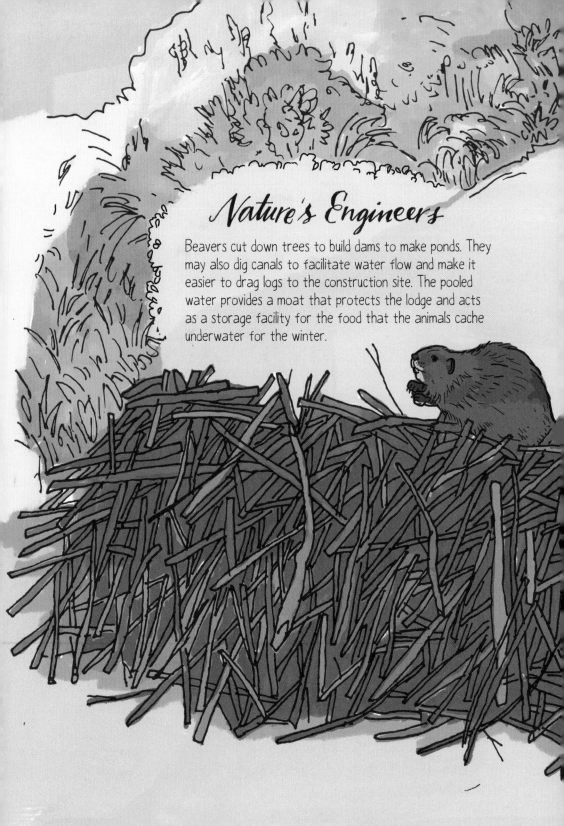

Nature's Engineers

Beavers cut down trees to build dams to make ponds. They may also dig canals to facilitate water flow and make it easier to drag logs to the construction site. The pooled water provides a moat that protects the lodge and acts as a storage facility for the food that the animals cache underwater for the winter.

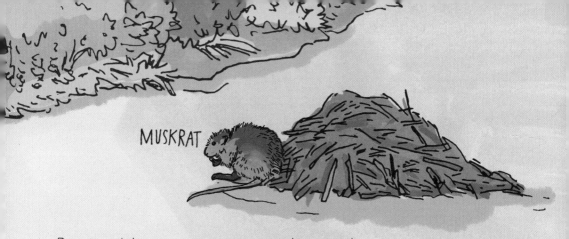

MUSKRAT

Beaver ponds have an enormous impact on the surrounding ecosystem, creating habitat for a host of other species. A family of beavers will typically work on a dam for many years, repairing it as needed to maintain the optimal level of water.

Muskrats do not build dams, and their lodges are made up of reeds and other marshy plants rather than branches and sticks. Both animals use mud to hold their lodges together and insulate them. Though they occupy an ecological niche similar to beavers, muskrats are more closely related to hamsters.

MAKING FURNITURE

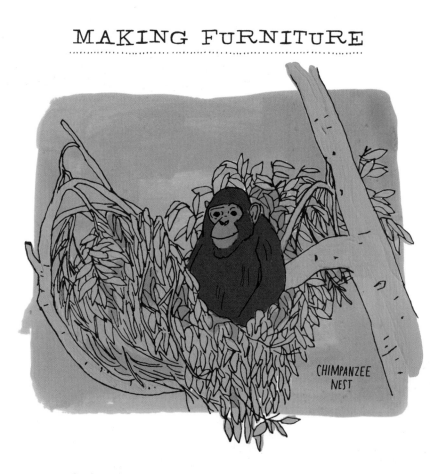

CHIMPANZEE NEST

Rather than building houses, chimpanzees, gorillas, and orangutans construct comfortable beds, which they use both for daytime naps and for overnight sleeping. These nests are typically not reused but built fresh daily.

It takes time to learn how to build a sturdy bed. Young great apes sleep with their mothers for up to three years before making their own nests.

Gorillas sometimes pile leaves and flexible branches
on the ground to take a nap during the day.

SOME PLANTS USED IN A GORILLA NEST

PANICUM

BRACKEN
FERN

TRIUMFETTA

CHAPTER 6

Weird and Wonderful

The Astonishing Octopus

There are some 300 species of octopus, ranging from the giant Pacific octopus (14 feet/4.3 meters long) to the 1-inch-long (2.5 cm) star-sucker pygmy octopus.

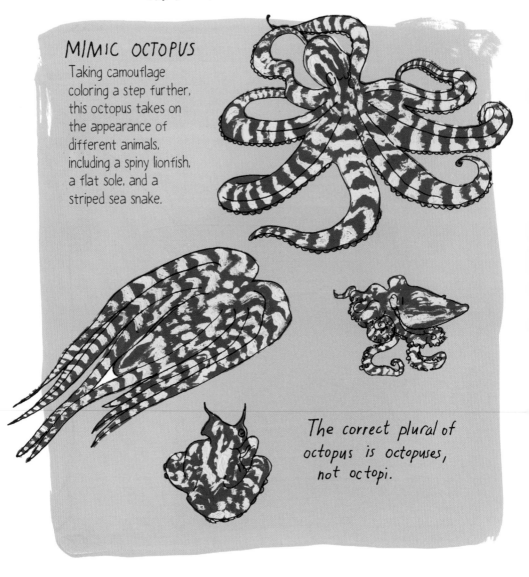

MIMIC OCTOPUS

Taking camouflage coloring a step further, this octopus takes on the appearance of different animals, including a spiny lionfish, a flat sole, and a striped sea snake.

The correct plural of octopus is octopuses, not octopi.

BLANKET OCTOPUS

Folds of tissue connect some of the arms of the female of the species, making them look like flowing capes when they swim. The females grow to be about 6 feet (1.8 meters) long. The males, in one of the most striking size differences in the animal kingdom, are just about 1 inch (2.5 cm) long!

COCONUT OCTOPUS

Considered one of the very few "tool-using" cephalopods, it gathers coconut shells to hide in, and sometimes even carries one along when moving about.

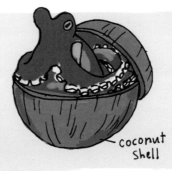

coconut shell

BLUE-RINGED OCTOPUS

Bright colors often warn off predators, and this tiny octopus is one of the deadliest creatures in the ocean. Its venom is 1000 times more powerful than cyanide.

SOME VERY BIG BIRDS

The spongy casque is covered with keratin.

DOUBLE-WATTLED CASSOWARY

- Related to the ostrich, emu, rhea, and kiwi
- 5-6 feet tall; females weigh almost twice as much as males
- Powerful legs and dagger-like toes for defensive kicks

GREAT BUSTARD

- Heaviest flying bird, at 35-40 pounds
- Lives in grasslands in Europe and Russia
- Omnivorous and largely silent

Bustards lack an opposable claw, so they cannot perch. They spend almost all their time on the ground.

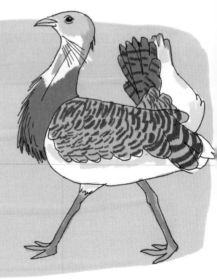

WANDERING ALBATROSS

- 11-foot wingspan, the largest of any bird
- Uses less energy flying than sitting on their nests
- Skims the surface of the ocean for prey
- Can live 50 years—pairs mate for life

DALMATIAN PELICAN

- Largest member of the pelican family
- Breeding males grow curly neck feathers and have a bright red lower bill

The throat pouch can hold up to 3 gallons of water!

SHOEBILL

- Up to 4½ feet tall with an 8-foot wingspan
- Also known as the whalehead
- Eats lungfish, eels, and even baby crocodiles

PLAYFUL AS A PLATYPUS

The platypus is one of only two types of monotremes, or egg-laying mammals (the other is the echidna). The eggs hatch after just 10 days, after which the female nurses her young for about 4 months. Platypuses feed on insects, shellfish, and worms, scooping them up underwater along with bits of gravel that help them grind their food before swallowing it.

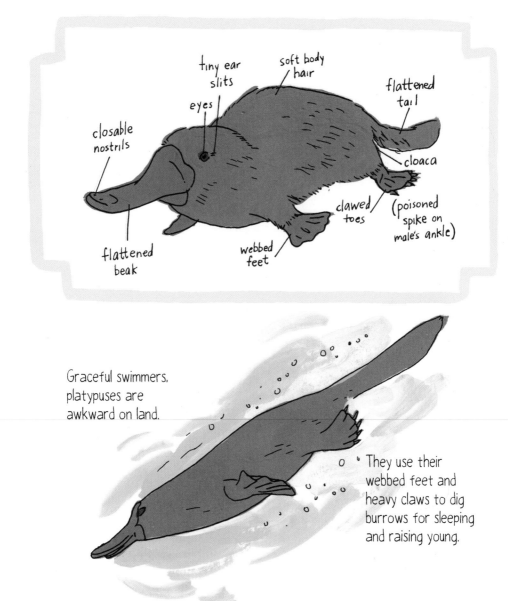

tiny ear slits

soft body hair

flattened tail

eyes

closable nostrils

cloaca

clawed toes

(poisoned spike on male's ankle)

flattened beak

webbed feet

Graceful swimmers, platypuses are awkward on land.

They use their webbed feet and heavy claws to dig burrows for sleeping and raising young.

Star-Nosed Mole

The only mole to live in swamps and marshes, the star-nosed mole locates prey by moving its exquisitely sensitive snout through the soil to pick up electrical impulses. The 22 fleshy tentacles that surround the nostrils are packed with more than 100,000 nerve fibers.

As it hunts, the mole touches 10 or 12 places per second to gather a mental image of nearby prey. Among the world's fastest eaters, it can find and consume a worm in a quarter of a second.

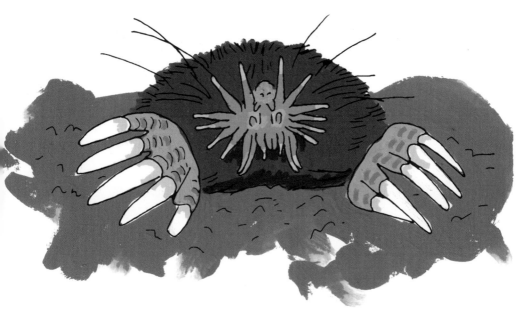

These moles are proficient swimmers and can even use their amazing noses to smell underwater by blowing out and quickly re-inhaling bubbles of air.

ANATOMY OF AN ARMADILLO

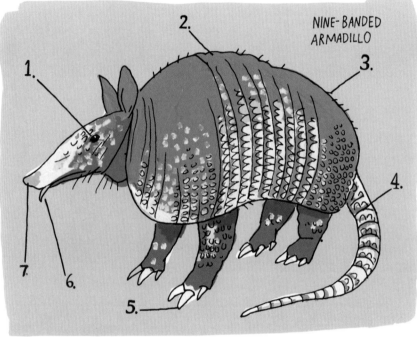

NINE-BANDED ARMADILLO

1. **eye** poor eyesight
2. **scutes** thick bony plates
3. **hairs** wiry hairs along sides act as feelers
4. **tail** scaly and long for balance
5. **claws** thick and strong for digging
6. **tongue** long for licking up insects
7. **snout** excellent sense of smell

There are 21 species of armadillo, all of which live in South America. Only the nine-banded armadillo, shown on the facing page, is also found in southern North America. They eat primarily insects but also plants, eggs, small animals, and some fruit. Armadillos are surprisingly good swimmers and can hold their breath for up to six minutes.

PINK FAIRY ARMADILLO

This tiny creature spends most of its time underground. It has huge claws and a flattened "butt pad" for packing dirt behind itself as it digs.

SCREAMING HAIRY ARMADILLO

The name says it all. The hairiest species of them all is also named for the loud squeals and moans it utters when threatened.

THREE-BANDED ARMADILLO

The only armadillo that can protect itself by curling into a ball. The others aren't flexible enough and either run or dig a hole to escape danger.

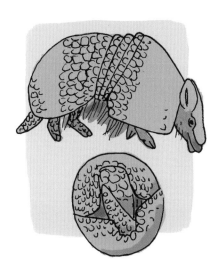

OTHER ARMORED MAMMALS

The pangolin and the echidna, like the armadillo, have protective armor. Though not at all related, they are both insectivores with long, sticky tongues for lapping up ants and termites, and heavy claws for tearing apart termite mounds and digging into the earth. And both are good swimmers.

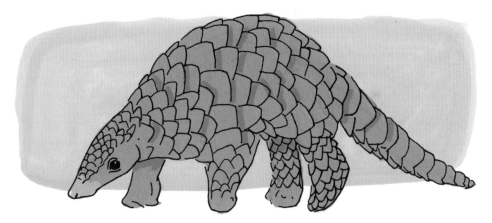

PANGOLIN

Sometimes mistaken for a reptile, the pangolin is unique among mammals in having sharp, overlapping scales over its entire upper body. Made of keratin, like fingernails and horns, the scales are believed by some to have medicinal value. Consequently, the pangolin is one of the most widely trafficked animals in the world.

There are eight species of pangolins, found in Asia and Africa. They range in size from about 12 inches to 39 inches in length.

A pangolin curls into a ball when threatened, completely covering all vulnerable parts.

ECHIDNA

Sometimes called a spiny anteater, echidnas do eat ants and other insects, but they are not related. They are one of two mammals that make up the order Monotremata, or monotremes—the only egg-laying mammals. The other is the platypus. There are four species of echidna, found in Australia and New Guinea.

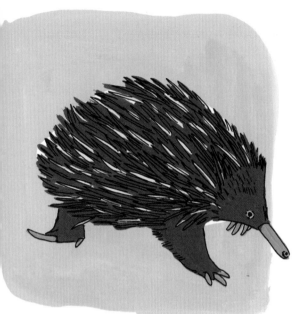

Like pangolin scales, the spines are made of keratin. When threatened, an echidna rolls into a ball or digs into the ground.

A baby echidna is called a puggle.

The female lays one leathery egg at a time, holding it in a temporary fold in the skin of her abdomen. When the blind, hairless baby hatches, it latches onto a teat and nurses for up to 12 weeks while it develops spines. At that point, the mother leaves her baby in a den but continues to nurse it for another six months.

AARDVARKS

ARE SO **ODD**

Ears like a rabbit, snout like a pig. Kind of kangarooish with a hint of badger around the claws. Even though it looks like it's made up of different animal parts and is somewhat related to elephants, the aardvark ("earth pig" in Afrikaans) is the only member of its own order, Tubulidentata.

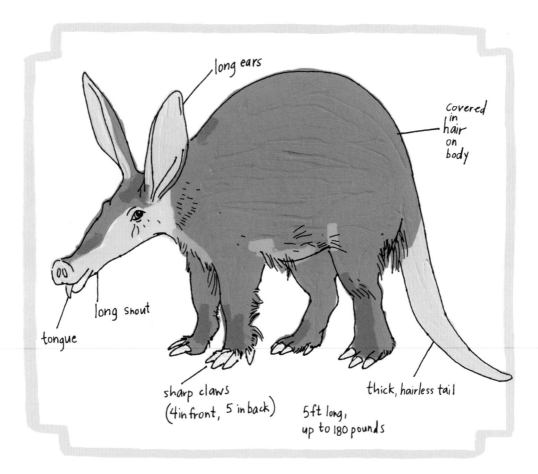

long ears

covered in hair on body

tongue

long snout

sharp claws (4 in front, 5 in back)

5 ft long, up to 180 pounds

thick, hairless tail

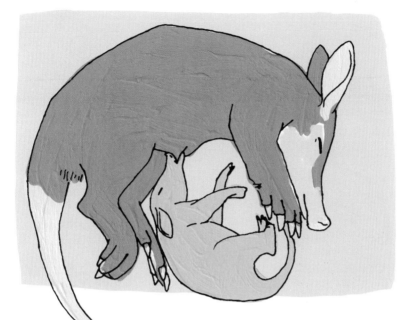

Those big ears and that long nose are for hunting ants and termites. The thick front claws tear apart anthills and termite mounds and dig sleeping dens.

Aardvarks eat mostly ants, termites, and other insects, but their diet includes a specific type of cucumber. *Cucumis humifructus*, or "aardvark cucumber," that grows about three feet underground. Its propagation depends on aardvarks digging it up and redistributing the seeds via their feces.

Aardvark Cucumber

Aardvarks' tongues are long (up to 12 inches) and sticky, great for catching insects.

LOOK, UP IN THE SKY

Bats are the only mammals that have wings and truly fly, but quite a few others have developed the ability to soar through the air with the greatest of ease. Many of them are marsupials.

COLUGO

Known as "flying lemurs," they are most closely related to primates. Strictly arboreal, they can barely move on the ground and are awkward climbers.

But using a very large membrane that is nearly square when stretched out, they can glide 230 feet (70 meters) while losing very little height.

FLYING SQUIRREL

There are some 50 species, found in many parts of the world, ranging in length (tail included) from about 6 inches (15 cm) to nearly 50 inches (1.25 meters).

GREATER GLIDER

Like the koala, this fluffy flying possum with a prehensile tail lives on a highly specialized diet of eucalyptus leaves.

SUGAR GLIDER

These social animals live in family groups where males help care for the young.

FEATHERTAIL GLIDER

This mouse-sized marsupial is named for its unusual tail, which looks like a quill fringed with stiff hairs.

BLACK AND WHITE ALL OVER

Pandas, zebras, penguins, and skunks are among the most famous black-and-white animals. This color scheme can serve as camouflage by breaking up the outline of the animal and helping it blend into the background. For other animals, like skunks, striking coloring warns off potential predators. A zebra's stripes seem to deter biting insects, for reasons scientists are still trying to determine. Here are a few less familiar, but still colorful, black-and-white animals.

Mini trunk can be used as a snorkel!

MALAYAN TAPIR

Adults look like they're wearing a white blanket or cape draped across their rumps. Babies arrive wearing spotted and striped pajamas for camouflage.

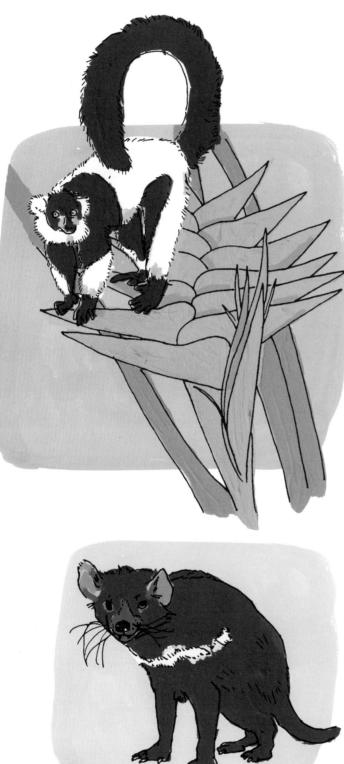

BLACK-AND-WHITE RUFFED LEMUR

Found only in Madagascar, this striking animal lives in small family groups in the forest canopy. Primarily fruit eaters, they are considered the world's largest pollinator, by virtue of their mutualistic relationship with the traveler's tree.

Unlike other pollinators, they can open the tree's flowers to get at the nectar. As they feed, pollen sticks to their fur and is carried from flower to flower.

TASMANIAN DEVIL

The world's largest carnivorous marsupial, the Tasmanian devil has fearsome incisors and one of the strongest bites of any mammal. It lives and hunts alone but prefers to scavenge. Numbers of them will gather around a dead animal in noisy groups that can be heard screeching and growling from a mile away.

Birds-of-Paradise

The more than 40 species in the family Paradisaeidae are known for the vibrant plumage of the males, who may sport brilliant patches of color, iridescent throat ruffs, or long feathers that trail behind them. Most males perform elaborate courtship displays to entice mates.

STANDARDWING
BIRD-OF-PARADISE

RIBBON-TAILED
ASTRAPIA

Birds-of-paradise primarily eat fruit; some also eat insects. Most birds-of-paradise are found in New Guinea.

WILSON'S
BIRD-OF-
PARADISE

MAGNIFICENT
BIRD-OF-PARADISE

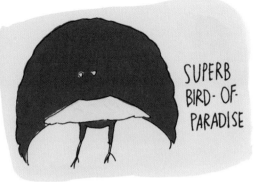

SUPERB BIRD-OF-PARADISE

A male Vogelkop superb bird-of-paradise raises his wing and tail feathers to provide a dramatic backdrop for his turquoise ruff and white eye patches.

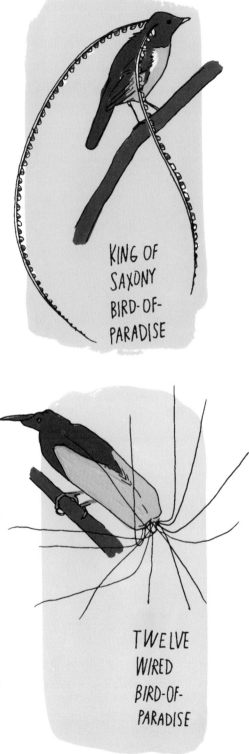

KING OF SAXONY BIRD-OF-PARADISE

GREATER BIRD-OF-PARADISE

TWELVE WIRED BIRD-OF-PARADISE

Capybara

Imagine a guinea pig the size of a small pig and you have the capybara, the largest rodent on the planet. They are superb swimmers, with partially webbed feet and coarse fur that dries quickly.

The young are precocial, meaning they can walk within a few hours of birth. Within a week, they begin eating grass and aquatic plants, though continuing to nurse.

Anteater

Giant anteaters are the largest of four species of anteater, all found in Central and South America. They can measure as long as 7 feet (2 meters) from nose to tail. When walking, they tuck their long front claws under and bear weight on their knuckles.

Anteaters have no teeth, but their long, sticky tongues are covered with thousands of tiny hooks. To avoid being bitten by their prey, they flick their tongues up to 150 times a minute, lapping up hundreds of ants at a time and swallowing them quickly. The bits of gravel and sand that are ingested at the same time help with the digestive process.

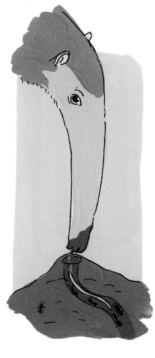

THE CuRious CHAMELEON

Chameleons do a lot of things most animals can't do, such as moving their eyes independently. They can change color at will, to regulate body temperature and communicate with other chameleons. They catch prey with their sticky tongues, which can move 13 miles an hour and may extend two times their body length.

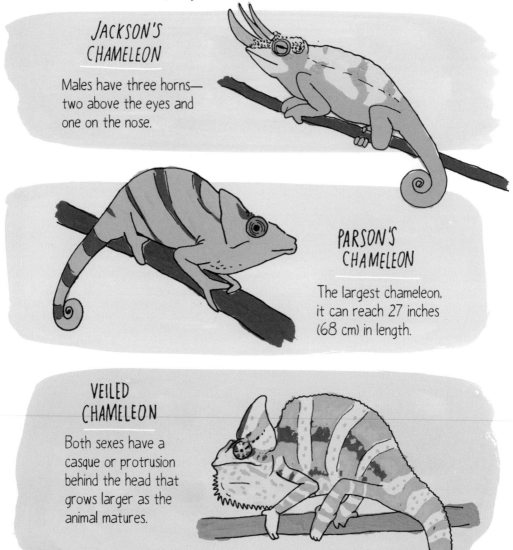

JACKSON'S CHAMELEON

Males have three horns—two above the eyes and one on the nose.

PARSON'S CHAMELEON

The largest chameleon, it can reach 27 inches (68 cm) in length.

VEILED CHAMELEON

Both sexes have a casque or protrusion behind the head that grows larger as the animal matures.

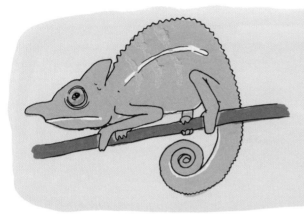

LABORD'S CHAMELEON

After an incubation of 7 to 9 months, this Madagascar native lives just 4 to 5 months. It is the world's shortest-lived land vertebrate.

CARPET CHAMELEON

Females are heavier than the males and more colorful. They may produce three clutches of eggs a year.

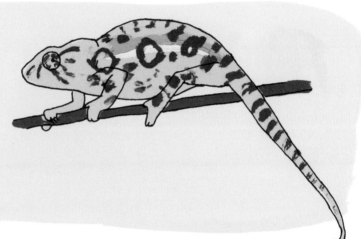

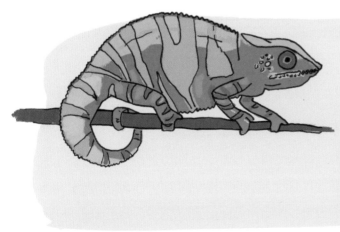

PANTHER CHAMELEON

Their coloration and patterns vary by location. They can be bright blue, green, red, or orange, with males being especially vibrant.

Chinese Giant Salamander

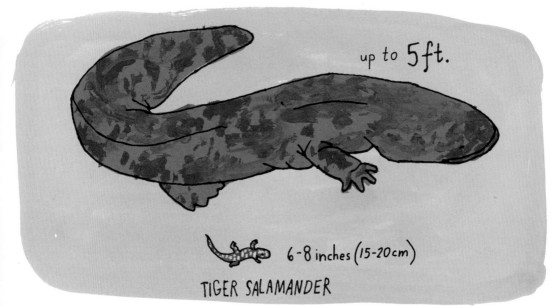

up to 5 ft.

6-8 inches (15-20 cm)

TIGER SALAMANDER

The world's largest amphibian is found in rocky rivers and mountain streams in China, where it is also farmed as a delicacy. This living fossil breathes through its skin and locates prey with sensory nodes along its sides that detect motion. An apex predator, it eats fish, frogs, shellfish, insects, and even smaller salamanders.

Females lay a string of eggs in a protected spot for the male to fertilize. He guards the eggs until they hatch but after that the young are on their own.

They release a sticky white substance from their skin when threatened.

Axolotl

The name (pronounced AX-oh-lot-ul) means "water dog" in the Indigenous Mexican language of Nahuatl.

The charming but mysterious axolotl defies all the rules of being a salamander by keeping its juvenile characteristics as an adult. These include webbed feet, a body fin, and immoveable eyelids. Though they develop rudimentary lungs, they remain aquatic, breathing through feathery external gills.

Found only in two lakes and a handful of canals near Mexico City, axolotls are hard to monitor in the wild but are widely studied in labs because of their remarkable regenerative powers. They can fully regrow any body part, including limbs, lungs, and even parts of their brain, in just a few weeks.

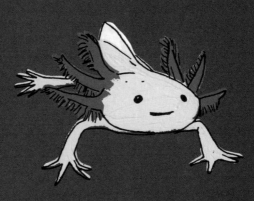

Purple Frog

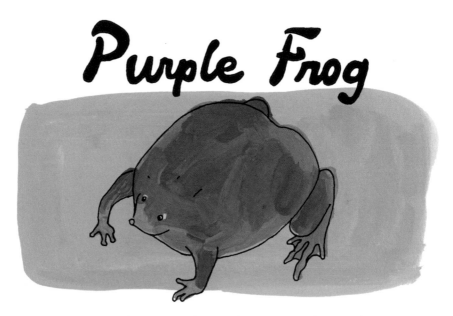

Also known as the pig-nosed frog, this rare animal is found only in a few places in India. Its exact status in the wild is unknown, but like many amphibians, it is considered endangered due to habitat degradation and loss, as well as human consumption of the tadpoles.

A fossorial or burrowing species, the adult frogs spend most of their lives underground, feeding primarily on termites. They emerge during the monsoon season to mate and lay eggs. The young are adapted to live in running water, where they use special mouth parts to cling to algae-covered rocks.

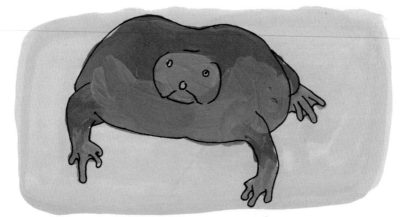

OTHER COLORFUL FROGS

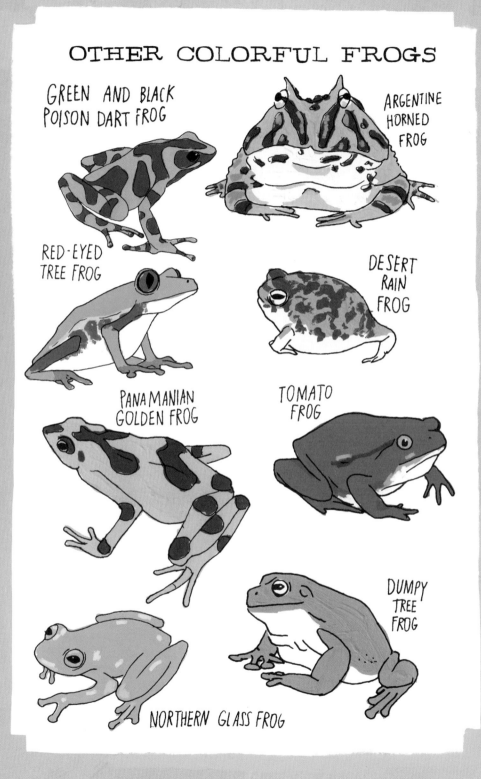

GREEN AND BLACK
POISON DART FROG

ARGENTINE
HORNED
FROG

RED-EYED
TREE FROG

DESERT
RAIN
FROG

PANAMANIAN
GOLDEN FROG

TOMATO
FROG

DUMPY
TREE
FROG

NORTHERN GLASS FROG

SNAKING ALONG

KING COBRA

In a threat display, the king cobra raises about one-third of its body several feet off the ground and flattens its neck ribs to appear larger. Its hiss is deeper than other snakes', sounding more like a low growl.

GREEN TREE PYTHON

Draped in coils on a branch, the green tree python wiggles the tip of its prehensile tail to attract prey, holding onto the branch with its tail when it strikes.

PARADISE FLYING SNAKE

This tree-dwelling snake can travel as far as 30 feet (10 m) by launching itself from a branch, flattening its ribs, and undulating through the air toward a targeted landing spot.

BRAZILIAN RAINBOW BOA

Named for its brightly colored, iridescent skin, this constrictor becomes sexually mature when it reaches a certain length, not a certain age.

BANDED SEA KRAIT

Though they hunt eels and can hold their breath for up to 30 minutes, these venomous snakes return to land to digest their prey and drink freshwater.

MALAGASY LEAF-NOSED SNAKE

These arboreal lizard hunters not only have unusual snouts, they are sexually dimorphic, meaning males and females have different appearances.

MALE

FEMALE

BLACK MAMBA

The highly venomous black mamba has olive or gray skin. Its name comes from the inky color of the inside of the mouth, which is displayed when the animal is threatened.

TENTACLED SNAKE

These small aquatic snakes sit still about 90 percent of the time, patiently waiting for fish to come within striking distance. The two small tentacles on the nose are thought to help it locate prey in murky water.

EYELASH VIPER

A venomous predator with raised scales above its eyes, the eyelash viper comes in an array of colors, including yellow, which allows it to hide in bunches of ripe bananas.

ANATOMY OF A VENOMOUS SNAKE HEAD

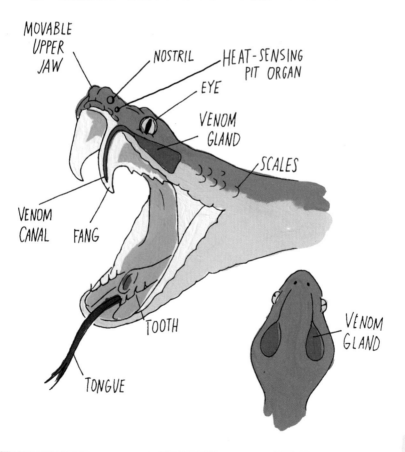

MOVABLE UPPER JAW

NOSTRIL

HEAT-SENSING PIT ORGAN

EYE

VENOM GLAND

SCALES

VENOM CANAL

FANG

TOOTH

TONGUE

VENOM GLAND

PANDA PARTICULARS

GIANT PANDA

Pandas are recognized worldwide for their fuzzy black-and-white fur and distinctive eyepatches, but scientists aren't certain what purpose the bicolored coat serves. Camouflage seems unlikely, as pandas have no natural enemies to hide from and no need to sneak up on prey.

These mostly solitary animals spend up to 16 hours a day foraging for bamboo, their only food source. They sit up to eat, grasping stalks with an elongated wrist bone that serves as a thumb and crunching them with powerful jaws and teeth.

RED PANDA

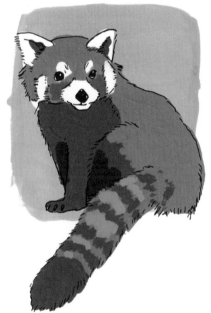

Although they share the same habitat and both eat primarily bamboo, red pandas and giant pandas aren't related. Red pandas used to be classified with raccoons but are now placed in their own family, Ailuridae.

They live mostly in trees where their luxuriant fur blends in with the reddish moss and white lichen on the trunks. Their thick tails make up half their body length. Furry footpads help them grip wet or icy branches.

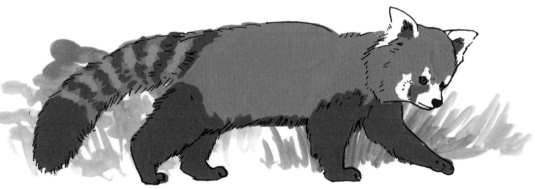

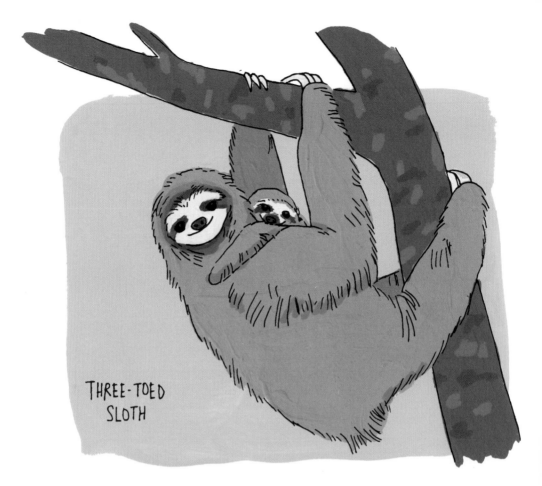

THREE-TOED
SLOTH

SLOTHS

The slow-moving sloth's leaf-based diet doesn't provide much nutrition, so it sleeps 15 to 18 hours a day to conserve energy. Its habits may resemble those of the koala, but sloths share a family tree with anteaters and armadillos.

All sloth species have three toes on their back feet, but they differ in having either three or two on the front feet. The claws are 3 to 4 inches long (8 to 10 cm) and can grip so tightly that sloths sometimes remain attached to a branch even after they die.

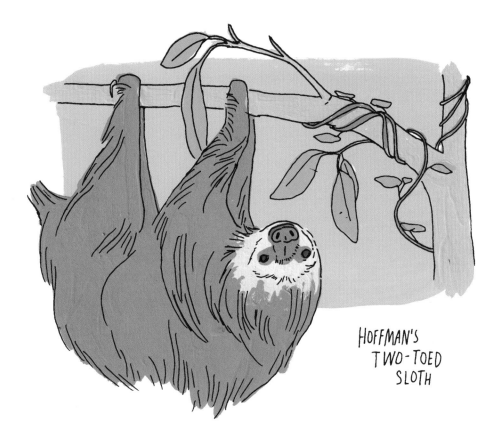

HOFFMAN'S
TWO-TOED
SLOTH

WAYS IN WHICH SLOTHS DIFFER FROM OTHER ANIMALS

- They do almost everything upside down, including give birth.
- Their fur grows upward from their bellies to their backs, helping shed water.
- The coarse fur has grooves where green-blue algae grows, creating camouflage.
- They have so little muscle mass that they are unable to shiver to keep warm.
- They poop just once a week.

Consider Helping

Here are some organizations who I think are working really hard to protect our wildlife. Thanks for considering donating to keep them funded!

African Wildlife Conservation Fund for Ugandan Student Graduate Degrees and Research (This is my sister's fund! See page 9 for more.)
https://wildlifenutrition.org

Yunkawasi (Peru)
www.yunkawasiperu.org

GERP Groupe d'étude et de recherche sur les primates (Madagascar)
www.gerp.mg

Australian Wildlife Conservancy (Australia)
www.australianwildlife.org

Bush Heritage Australia
www.bushheritage.org.au

Giraffe Conservation Foundation (Africa)
https://giraffeconservation.org

Panthera (Global)
https://panthera.org

Save Cambodia's Wildlife (Cambodia)
www.cambodiaswildlife.org

Golden Triangle Asian Elephant Foundation (Thailand)
www.helpingelephants.org

Kiara (Indonesia)
https://kiara-indonesia.org

Conservation Through Public Health (Uganda)
https://ctph.org

THANK YOU!

Thanks as always to all the kids (and adults!) who wrote to me and gave me the motivation to do another one of these books, which take so long!

Thanks, Lisa Hiley, for all the captivating animal factoids and meticulous research on all the creatures.

Thanks always to Deborah Balmuth, art director Alethea Morrison, Alee Moncy, and the entire staff of Storey Publishing who are a huge pleasure to work with.

Thanks to Mara Grunbaum for the fact-checking.

Thanks to Casey Roonan for all the painting and scanning help. And the singing.

Thanks to my family and friends who give me so much support.

Thanks to everyone who helps to conserve our Earth's incredible wild kingdom (especially my sister).

FaceTiming with my sister and a baboon!